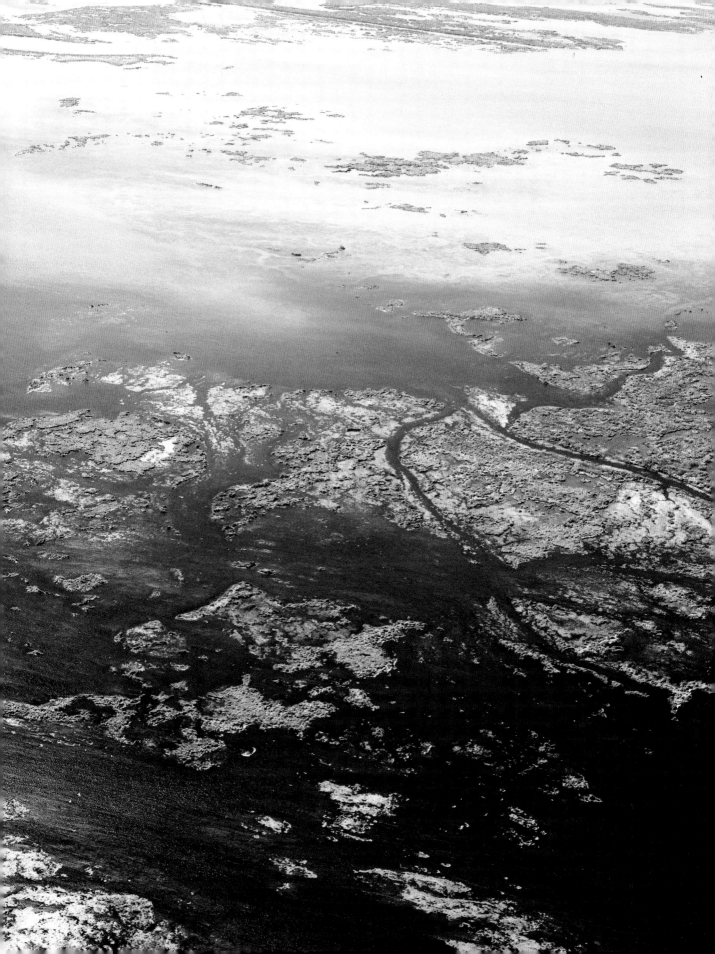

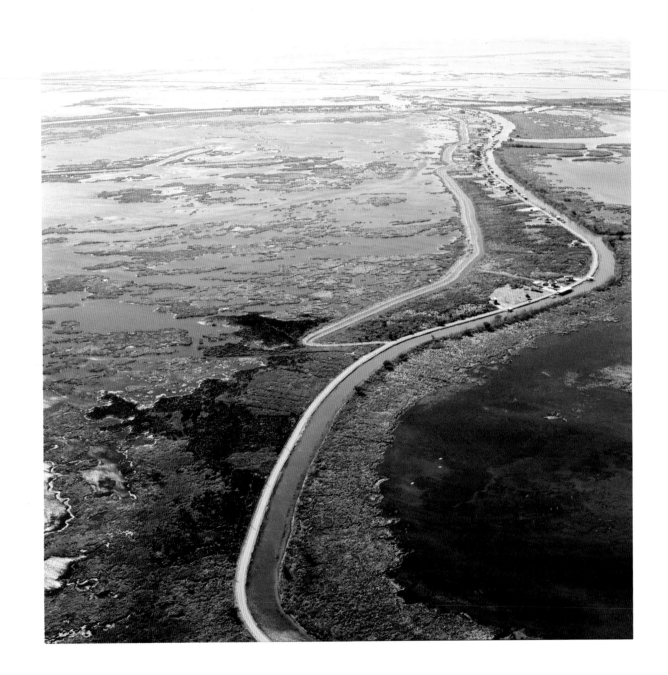

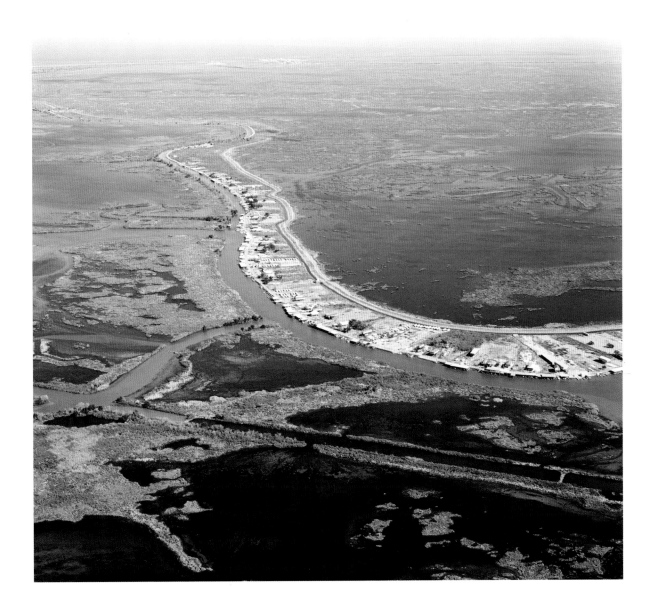

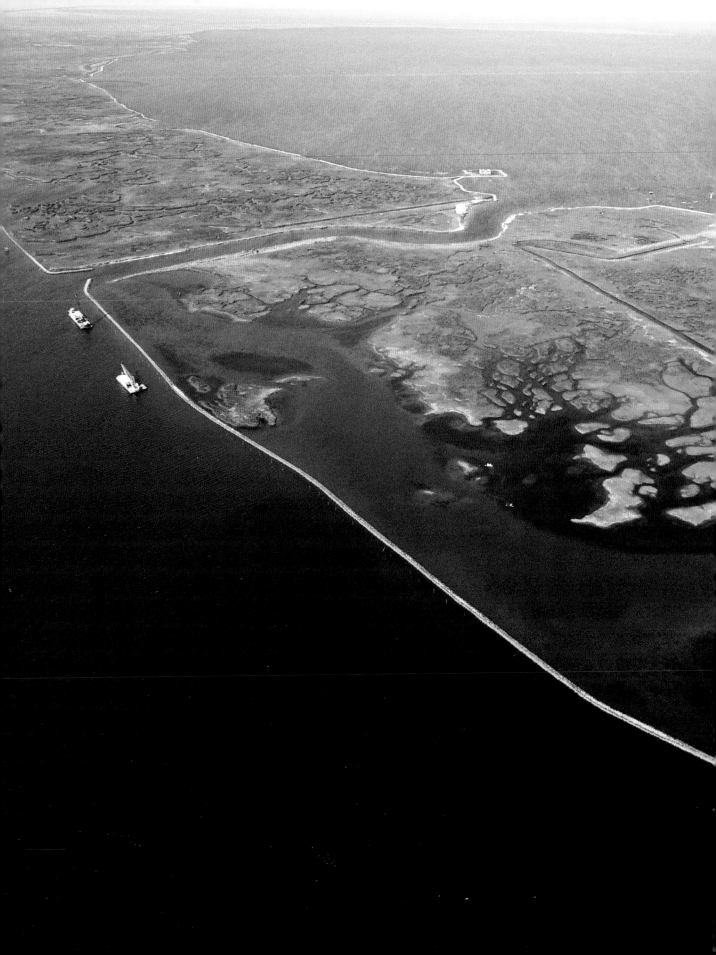

Fish Town

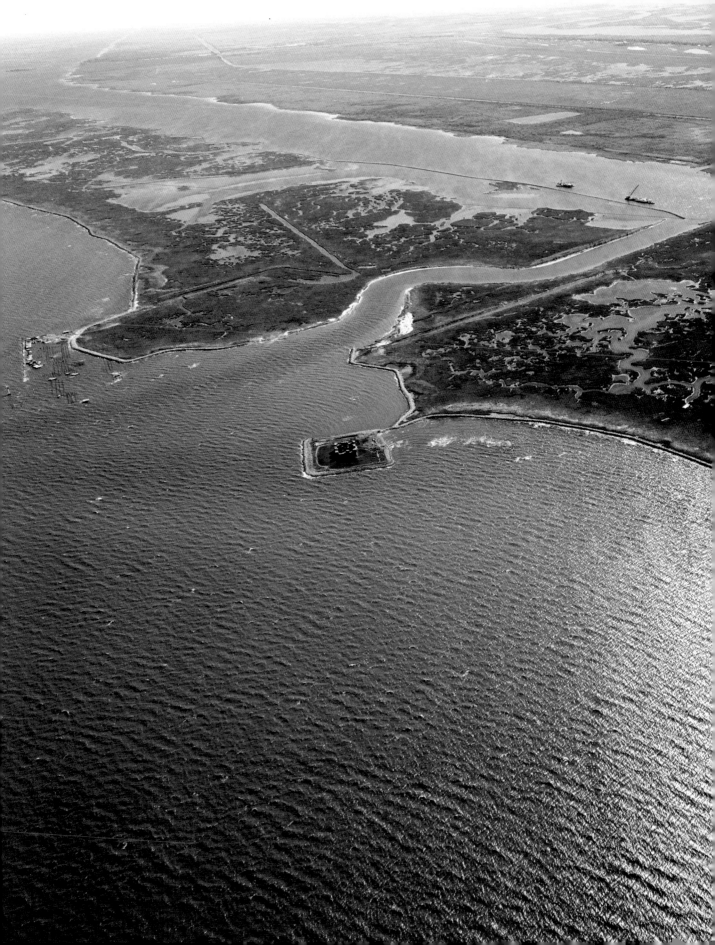

That's where I belong: I belong on the water.
Been on the water all my life. Whenever I open
my door, I've always seen a bayou or a lagoon.

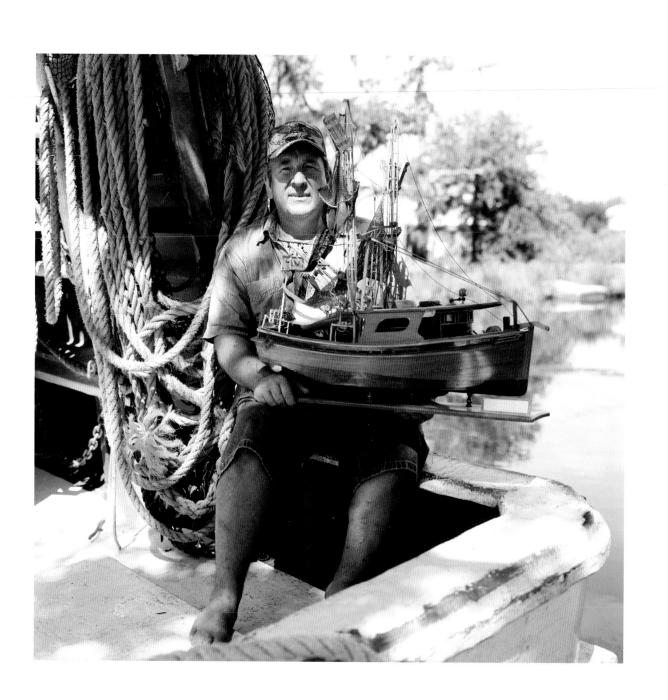

Fish Town

Down the Road to Louisiana's
Vanishing Fishing Communities

Photographs and text
by J. T. Blatty

with recollections by residents
of the fishing communities
and a concluding essay
by Craig E. Colten

GEORGE F. THOMPSON PUBLISHING
in association with
THE AMERICAN LAND PUBLISHING PROJECT

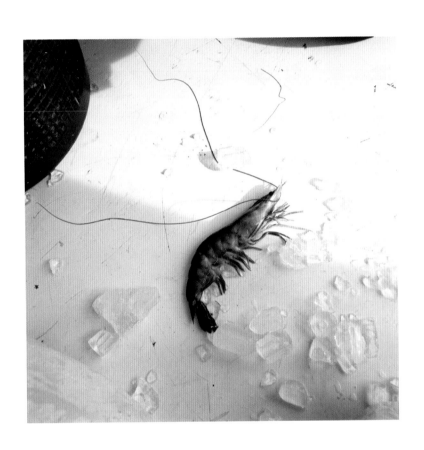

Down the Road

"Down the road" is away from the city. It's across the bridges, highways, and interstates diverging from New Orleans like arteries diverge from the heart, an aquatic maze of intersecting bayous, lakes, and canals feeding into the seemingly infinite wetlands of southeastern Louisiana.

Down the road is through a levee gate, a portal through a metastasizing landscape, where ridges of lush green oaks transform into a forest of skeleton trees at the moment of crossing through the threshold. It's the last road, like old U.S. 51 or the Florissant Highway, a one-way in and a one-way out. The further you drive, the more it winds, running parallel to a canal that, for many, has been treacherous by night. It becomes the only high ground, a narrow corridor above a depressed landscape of tall marsh grass and swamps littered with blighted boats, debris, and machinery moved by years of hurricanes and disasters. It's where a great blue heron launches into flight, its dangling feet barely scraping your windshield as it spreads its wings across a stormy sky tainted by a power plant looming in the distance.

Down the road is across the last drawbridge, into a town with a lone convenience store and a tiny marina selling only bait and fuel, where the air's scent is that of sweet marsh mud at low tide mixed with diesel fuel and seafood left rotting under the sun. It's the last mile of high ground, hugged in between land and water. On one side, long driveways give way to stilted trailer camps teetering twenty feet above the ground, broken by stretches of empty lots of piling remains, cracked concrete slabs, or trailers with neatly stacked crab traps. On the other side, anchored boats rest in between abandoned, battered docks, while the sound of animated chatter from the only dock with a heartbeat echoes across the water with the incoming tide, from the dockside drift of seafood buyers conversing with the captains and deckhands idling slowly out to sea.

Down the road is a where a stranger isn't a stranger for long and the only person to communicate with is the person standing right in front of you. It's a place that seemingly floats on the edge of the world, and it always ends abruptly where the water meets the land.

Yscloskey native Charles Robin III, a seventh-generation commercial shrimper, stands on the stern of his pride and joy, the *Ellie Margaret*, tied down to the same wooden pier his family used generations before, adjacent to a nearly empty stretch of land that was once his home. It's where, as a teenager, he watched his father build the wooden-hulled trawler in their backyard with his own hands, the same ship he now captains. Squinting against the sun on a perfect blue-sky day, he looks out over the bayou towards the remains of a small, scarred shrimp boat tossed up against the bank, reminiscent of a different time, of a childhood growing up in a tightly woven fishing community that was bound by the rich, wild paradise surrounding them.

"You should've seen it; this was God's country," he tells me, speaking of a time when freshwater lakes and bayous mingled with high ridges of native oak, cypress, sycamore, and fruit trees. It was a time when every driveway had a home and every home came hand in hand with a boat tied up in the bayou a stone's throw away, sometimes a boat where the entire family, from infant to great-grandfather, spent weeks out at sea together, dragging their shrimp nets and living a simple life.

For villages like Yscloskey, this was a way of life even before the first settlers arrived during the late 1600s, when native tribes such as the Chitimacha, Choctaw, and Houma navigated the bayous on wooden pirogues and twenty-passenger canoes carved from hollowed-out cypress trees. Some tribes can be traced as far back as 6,000 years ago, making them some of Louisiana's earliest maritime cultures that would later influence and become immersed in the small fishing communities established by the earliest to latest settlers: the Spanish-speaking Canary Islanders (Los Isleños); French merchants from Nova Scotia (Acadians); Dalmations; Africans, runaway slaves, and "gens de couleur libres" (freed men and women of color before the abolition of slavery); Filipino "Manila Men"; and a collage of international migrants. They all found a natural paradise along southeastern Louisiana's wetlands and never had a reason to leave or travel to the urban world, which seemed endless miles away. Everything they needed or wanted surrounded them—fish, fruit, fur, meat, sugar, and vegetables—they were all at their fingertips, whether they fished, hunted, or harvested them or bartered with their next-door neighbors.

Looking at the landscape now, it's hard to believe it ever looked the way Charles describes it and even harder to believe that, during the course of his lifetime, he's seen the land and his own community nearly vanish in front of his eyes. While Yscloskey is still a hub for a few native fishermen such as Charles, it's primarily a staging area now, a place for them to tie up and maintain their boats in between trips, leaving it a near ghost town once the work day is over. Most, if not all, of the native residents moved their homes to different towns on higher and dryer land north of the levee, while the bright, fresh world that Charles once knew is now close to an apocalyptic wasteland with a bayou running through it. Electric poles protrude from the swamps like crosses alongside bare, skeletal trees, while, in some towns, the carcasses of handmade vessels that are halfway to an underwater graveyard far outnumber the boats still bobbing above the water.

It's no secret that the fresh seafood industry has been on a downward spiral for decades, but hiding in the economic shadows are the unique fishing communities along Louisiana's Gulf Coast that made New Orleans the Mecca of fresh seafood dining and that have either already vanished or are quietly slipping into extinction. In addition to the challenges faced by the industry as a whole—competition against cheaper imports, fluctuating fuel costs, and the rampant mislabeling of fresh seafood in markets, to name a few—these historic communities also rest atop a "sinking land" and for years have been plagued by natural disasters such as Hurricanes Betsy (1965), Katrina (2005), and Isaac (2012) and man-made disasters such as the Deepwater Horizon oil spill (2010). According to the United States Geological Survey, Louisiana has lost more than 1,800 square miles of wetlands since 1932, and approximately seventeen additional square miles are lost annually; this means an area the size of a football field vanishes every hour.

Charles's grandfather was present to witness the earliest warning signs as a child, when a ten-foot storm surge from the big hurricane of 1915 sent him and his family twenty miles inland from their home in Shell Beach on their fishing boat. Fast-forward ninety years to Hurricane Katrina: While the world looked at the devastation in New Orleans from their television sets, twenty-five-foot waves barreled over rooftops in towns like Yscloskey, Shell Beach, and Hopedale, towns that stood naked without the old natural buffer to protect them from the surge, for the outer-lying barrier islands had already been swallowed up by the Gulf of Mexico.

Many believe that New Orleans was built upon land that should never have been occupied, and I'd say even that the early territorial governor, Jean-Baptiste le Moyne de Bienville (1680–1767), and the first French settlers knew they were susceptible to Mother Nature's fury, even on the little high ground they found for their city, or else they wouldn't have built the first man-made levees along the adjacent Mississippi River. But they would not have known the impact of those levees and how they would restrict the natural flooding of a great river that is meant to replenish the surrounding lands with rich sediments and minerals. As New Orleans continued to expand and develop around its strategic port over the centuries, so would its levees, becoming the current system that continues this restriction to a much higher degree.

Acceleration of a coastal, ecological disaster became far more clear with the arrival of the oil companies during the late 1920s, when they began dredging canals through thousands of miles of wetlands to lay pipeline for thousands of oil rigs that are now abandoned in those wetlands and in the Gulf of Mexico; some of those canals have since expanded many times their original size. Then came the U.S. Army Corps of Engineers during the late 1950s and early 1960s and the creation of the Mississippi River-Gulf Outlet (the MR-GO or "Mister Go"), for which the Corps dredged through seventy-six miles of wetlands, right through eastern St. Bernard Parish and the entire coastal town of Shell Beach to create a major shipping passageway from New Orleans to the Gulf of Mexico. As one retired commercial fisherman told me, "That's how we got saltwater intrusion. That's how, when you come down the highway there, you see all them big ol' beautiful trees, all dead. They look like they petrified. Where the buoys are? They used to be on land; now, they in the middle of the ship channel."

As saltwater continues to eat away and engulf the marshlands of coastal Louisiana, it's taking along with it a piece of unique American history—a way of life and a distinct Southern culture that have thrived here since the late 1600s and counting. With each passing year, down the road takes on new meaning.

Since 2010, I've been traveling down the road to these places where my grandparents in New Orleans came to escape, to fish amongst the high marsh grass and gather around crab and crawfish boils like so many other New Orleanian families have been doing for generations. Like me, all were drawn to the people and the landscape that I now call Fish Town.

I did not begin this project with the mission or voice of an activist, because I simply do not have the answers to how we can save both the land and its fishing communities, and I can't claim to know what's best for everyone in a region of uniquely independent people. But, through the photographs and recollections in this book, I can try to preserve what is left and make sure there will always be a story of this place once it is gone.

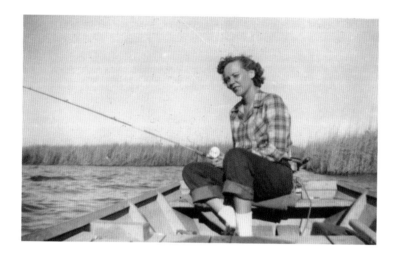

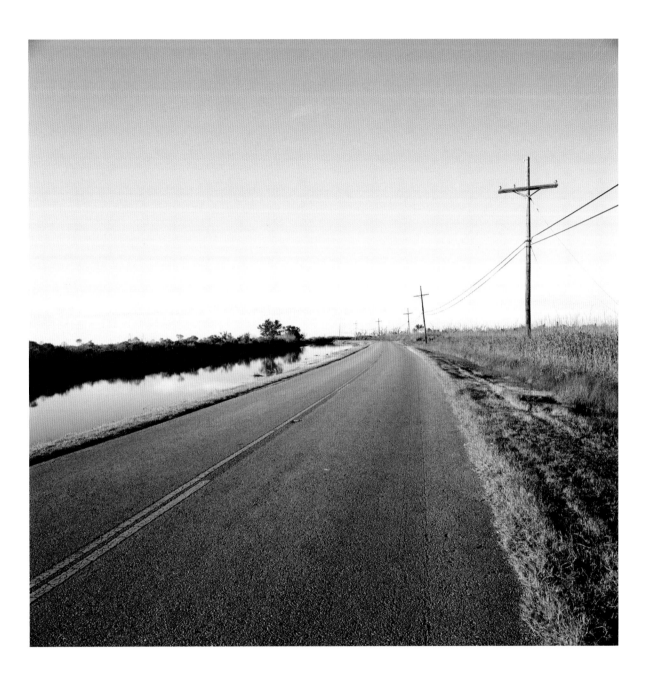

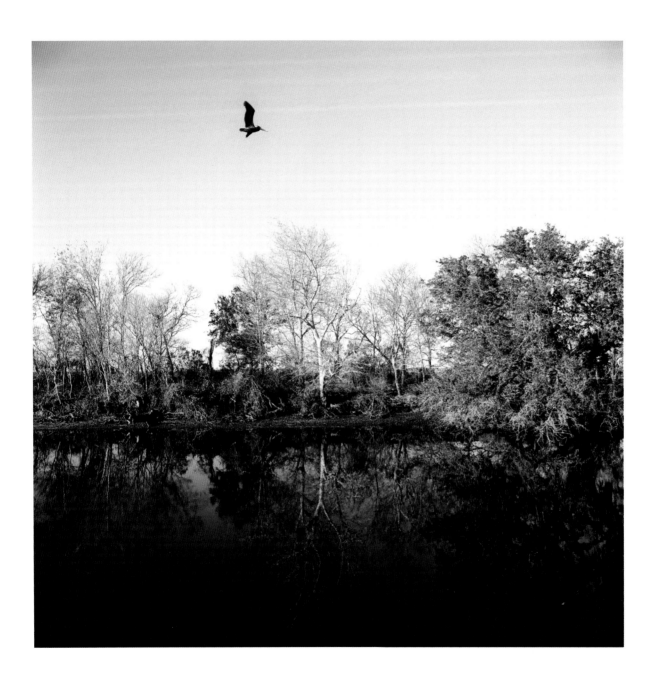

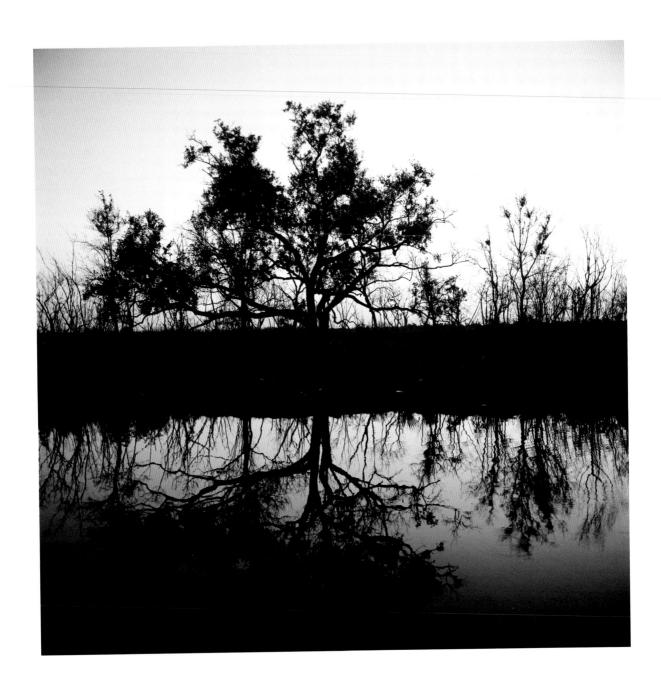

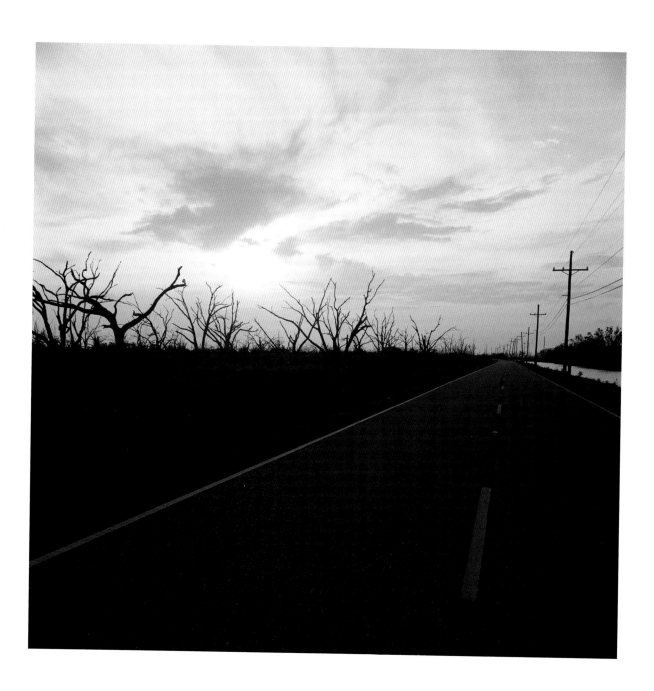

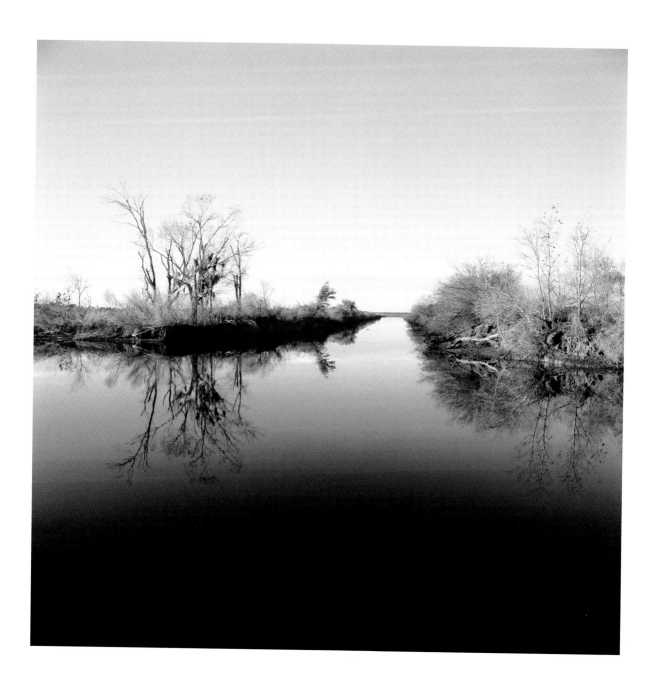

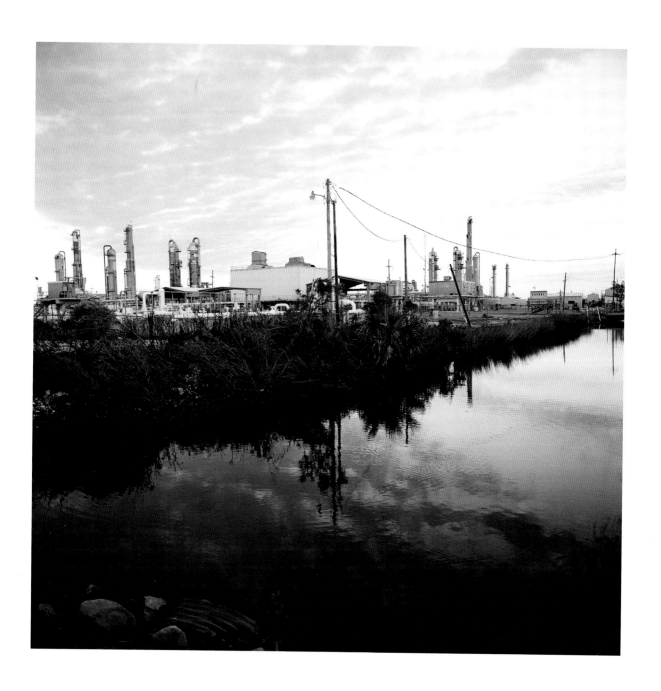

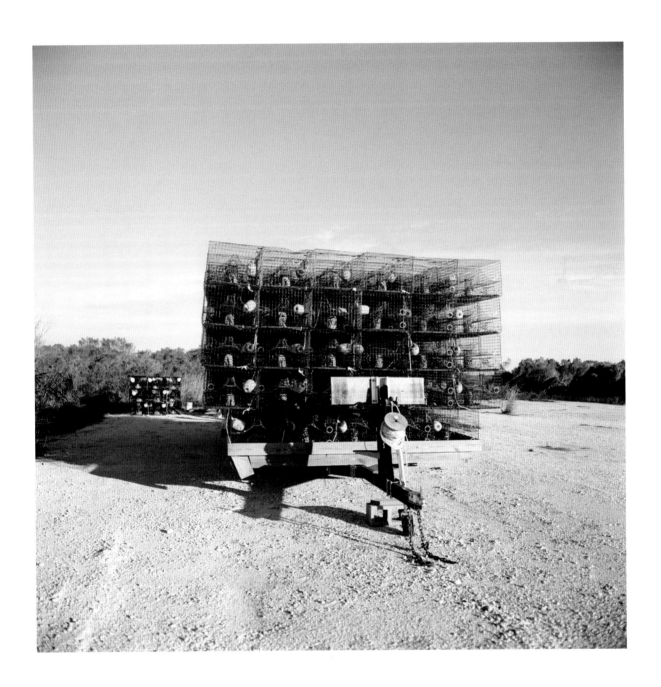

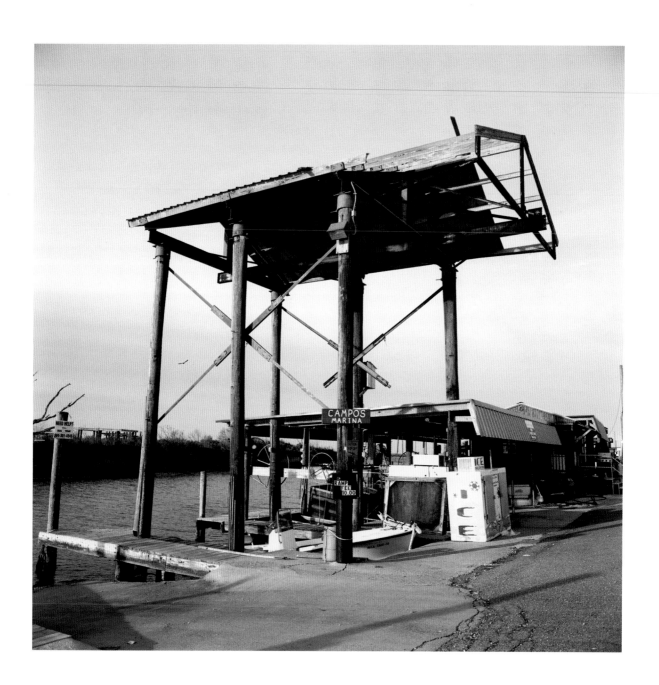

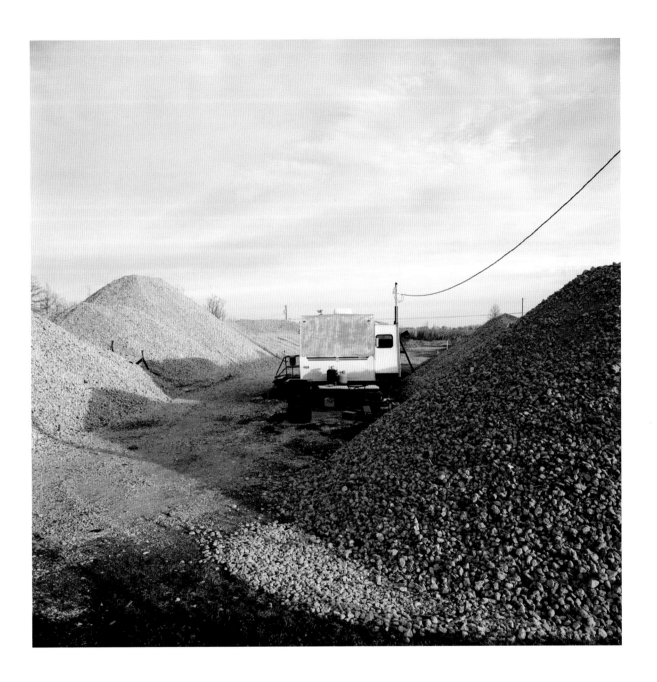

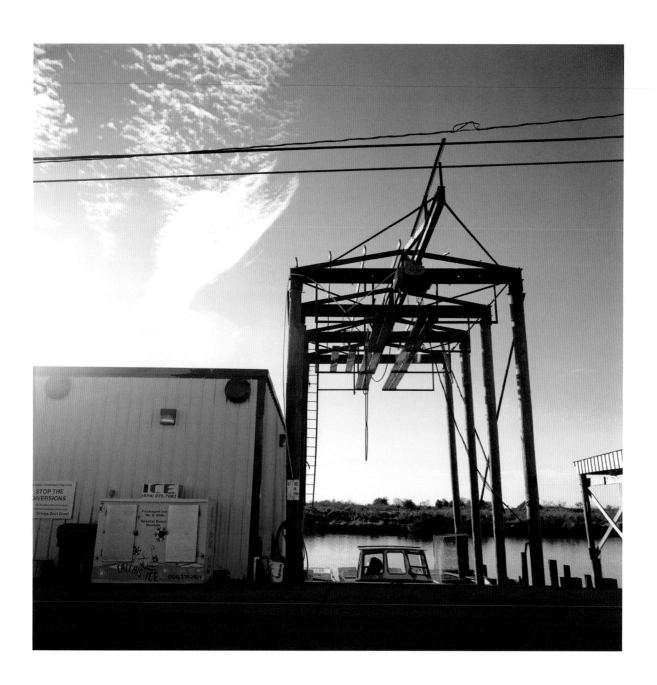

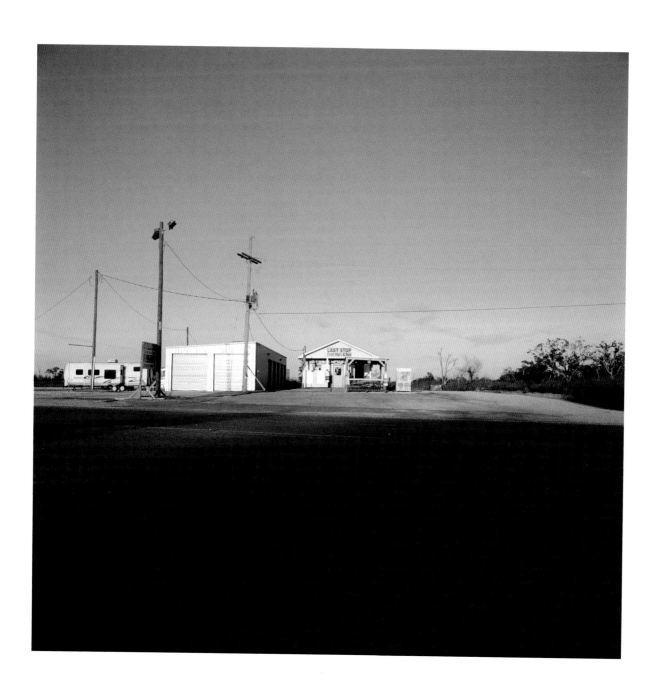

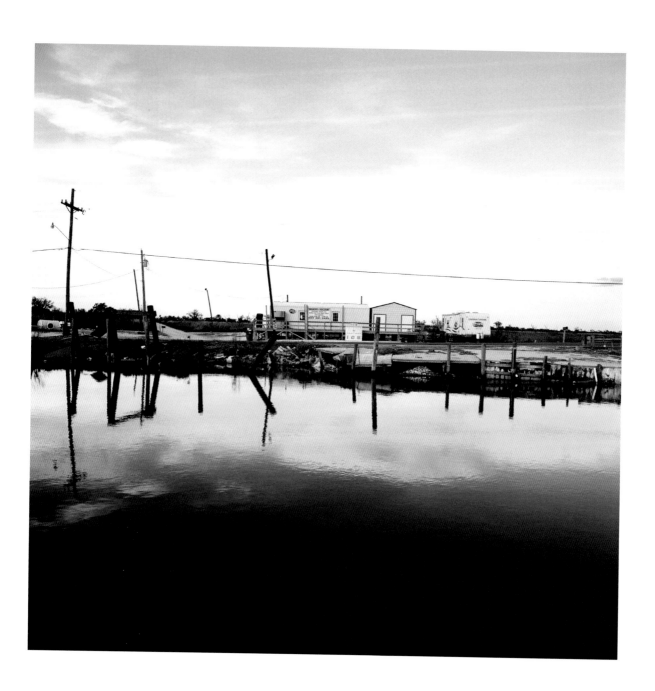

I close my eyes,
and I could tell you
who lived here.

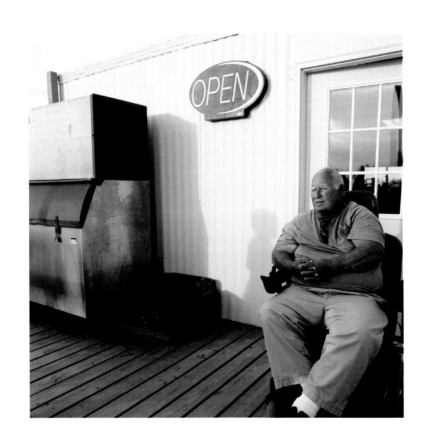

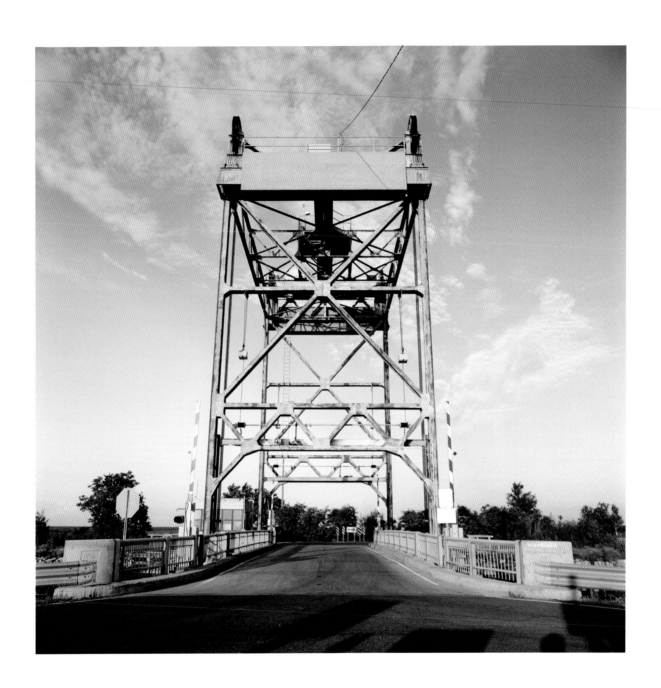

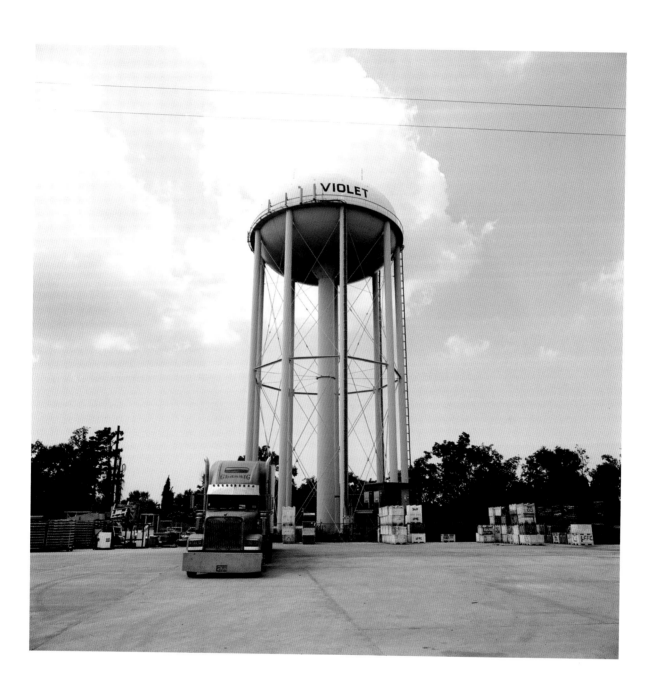

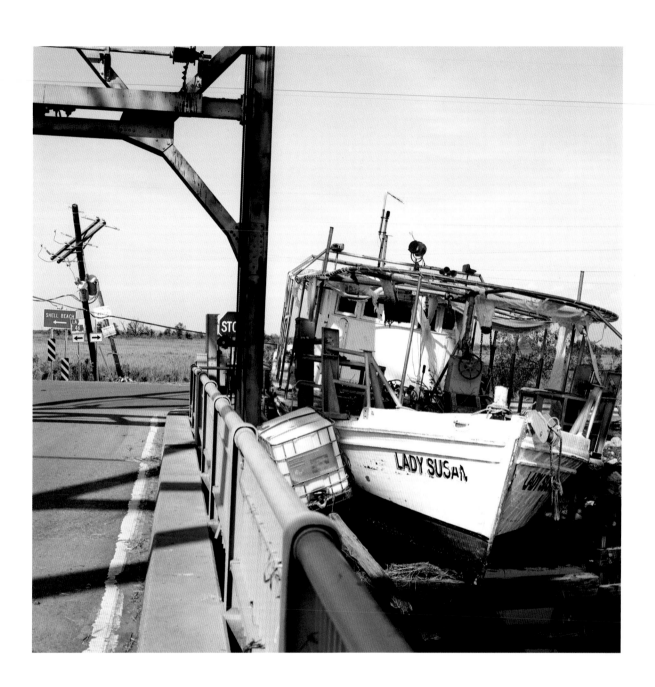

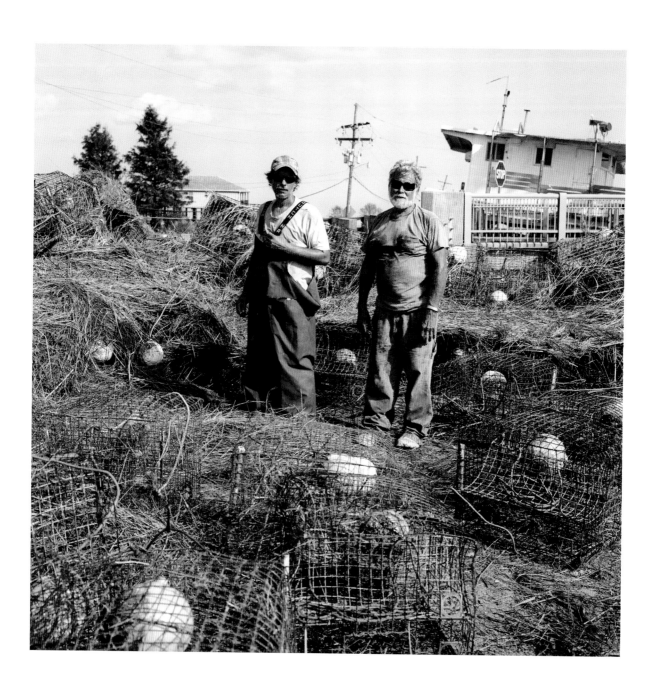

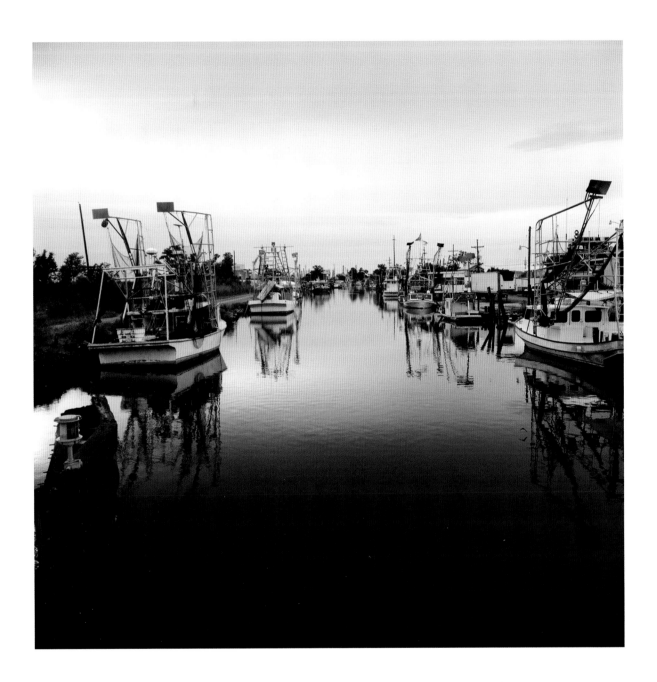

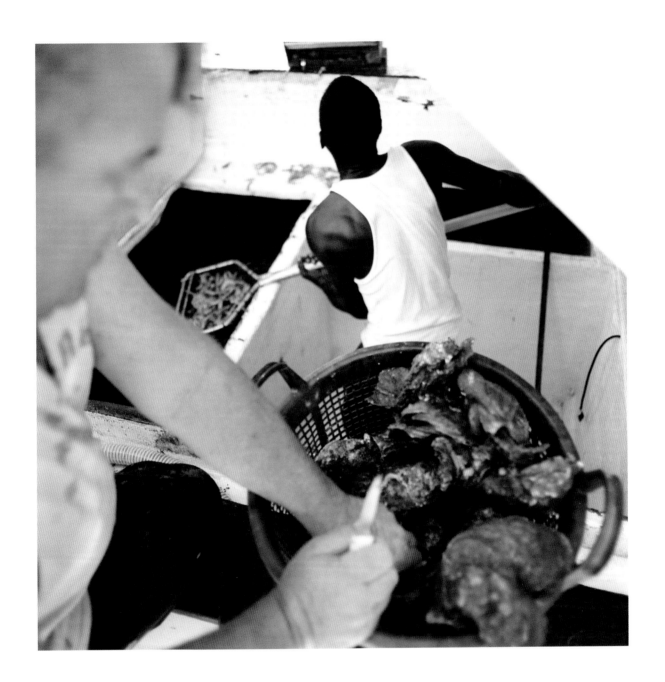

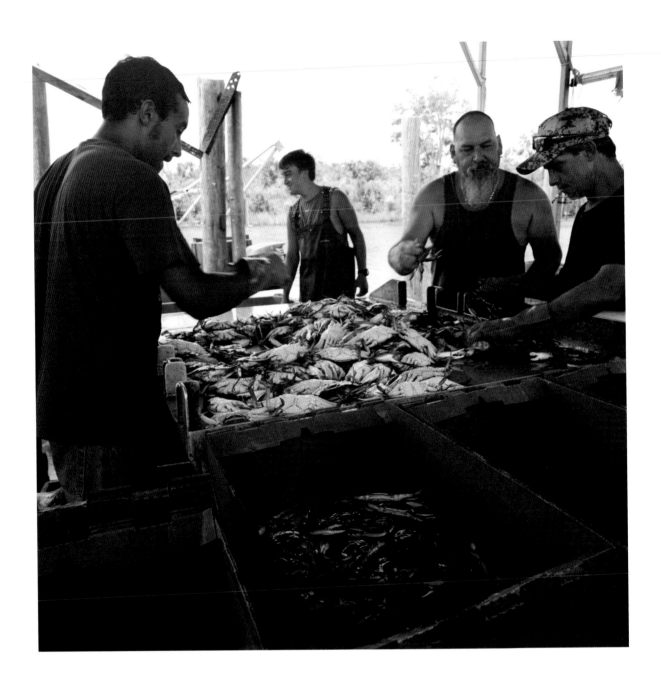

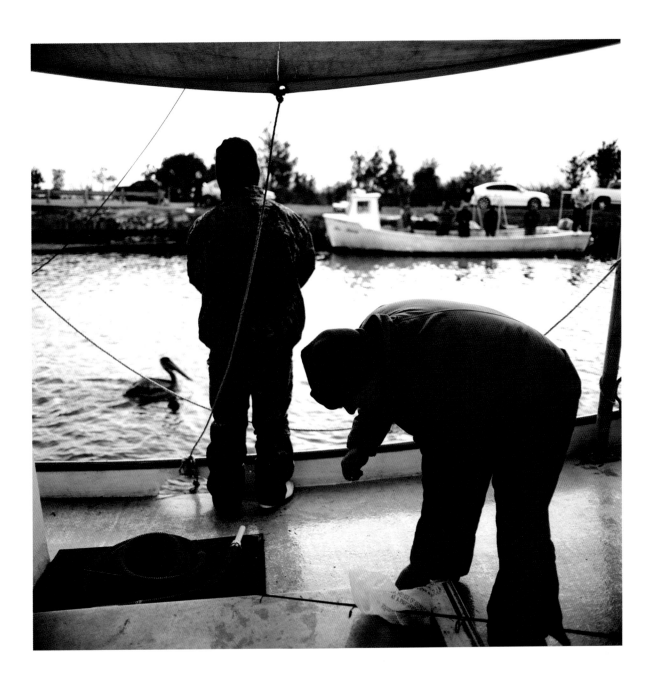

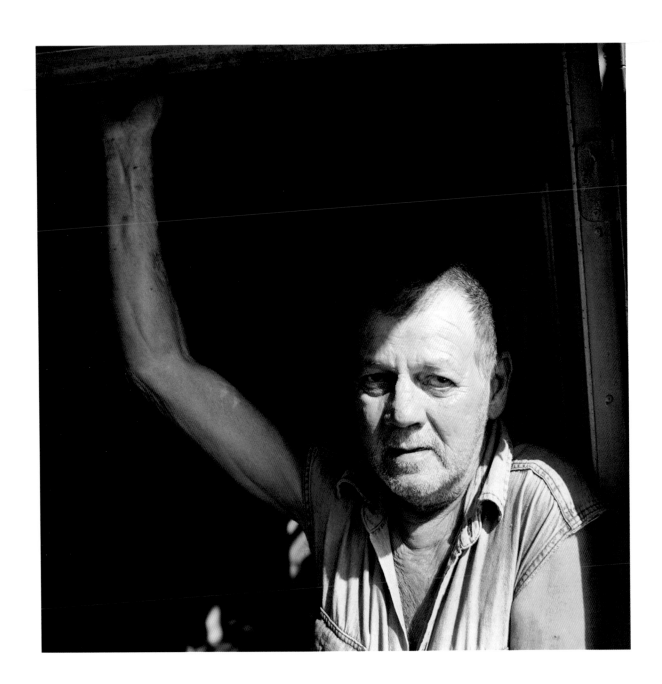

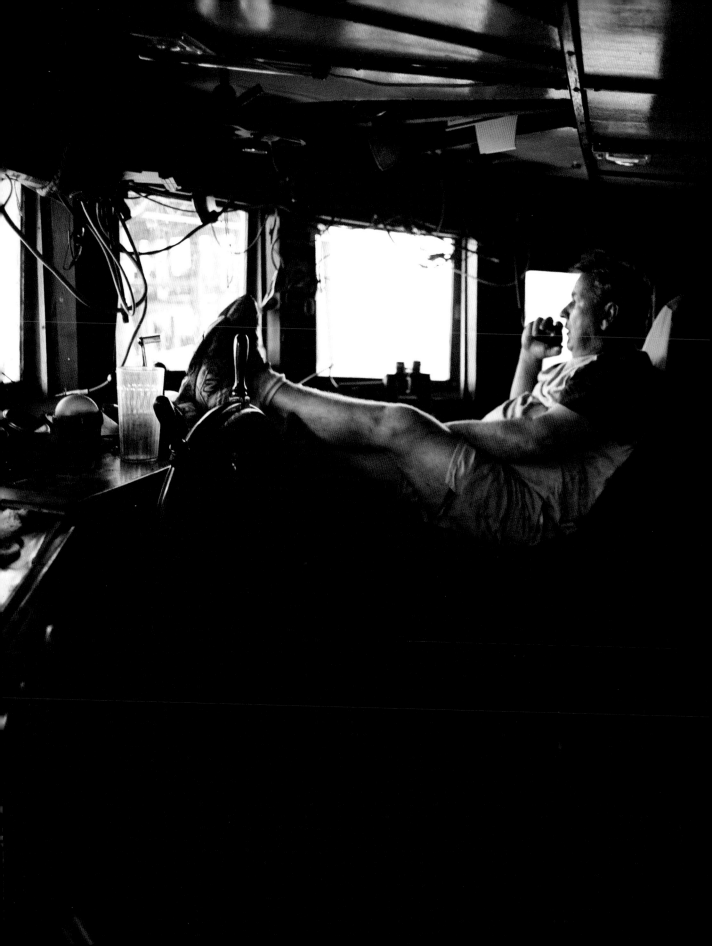

Most of the time when my grandpa came,
we was all together: me, my dad, and him
on the big boat. My grandpa used to tell
me things, you know, certain conditions:
"This is where you're gonna find shrimp,"
or "This is what you gotta do to catch them."
He used to teach me how to sew nets
together. He started fishin' with his Dad
at a really young age. That's all he ever did,
ever since he was about five, six years old.
My little boy, now he's ten. I've taken him
out here with me on the weekends.
He says, "I want to be just like my Dad,
I wanna do this."

My Daddy was one of the best fishermen
in this area. Don't need a radio, you know?
Looked at the weather. I got a picture of my
grandfather; he was around eighty years old
and fishin' with a net.

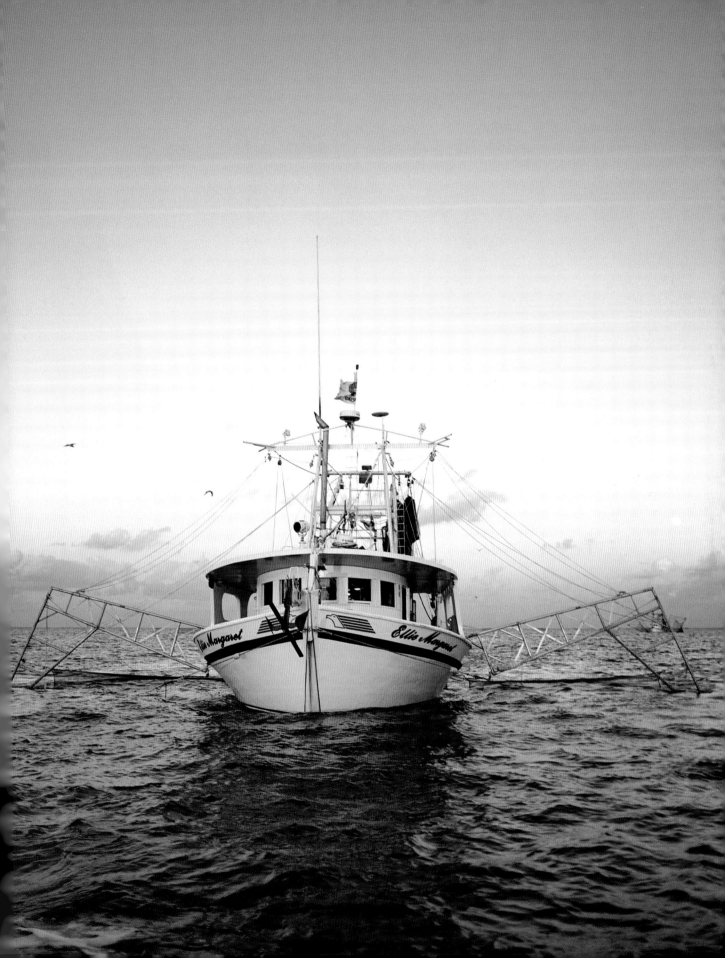

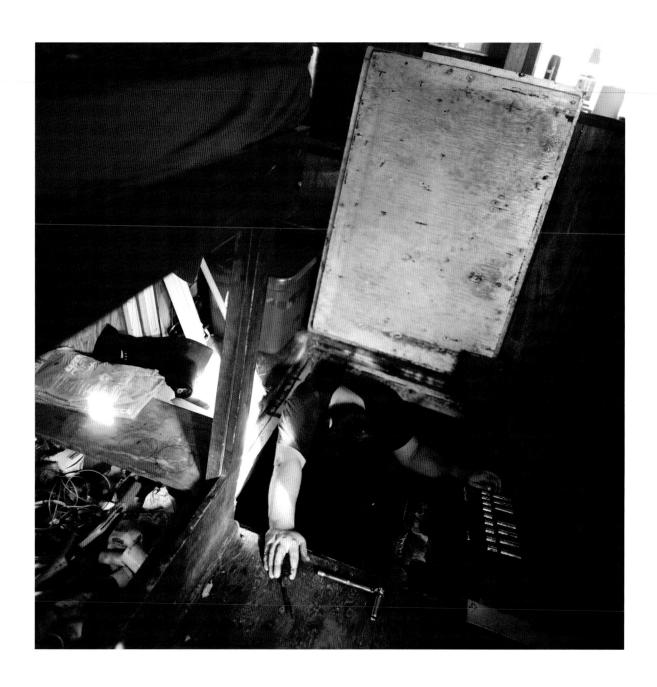

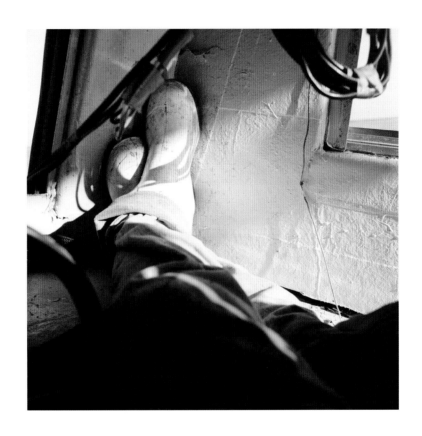

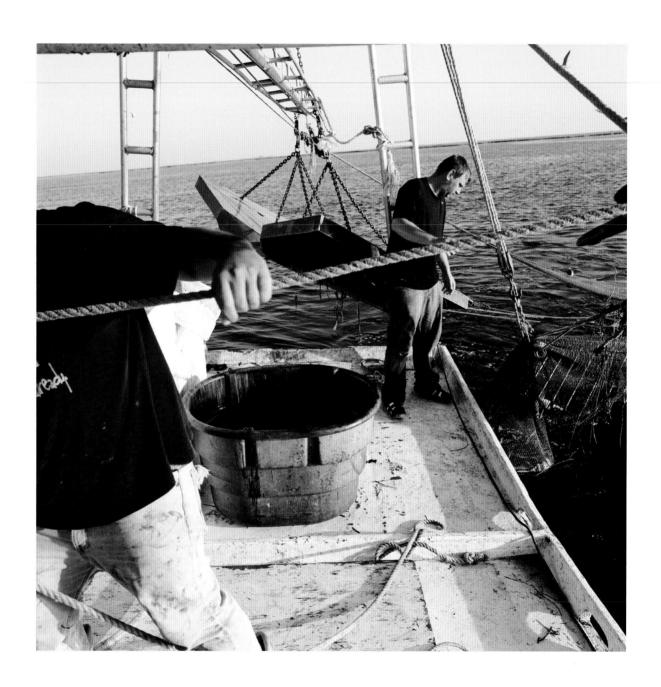

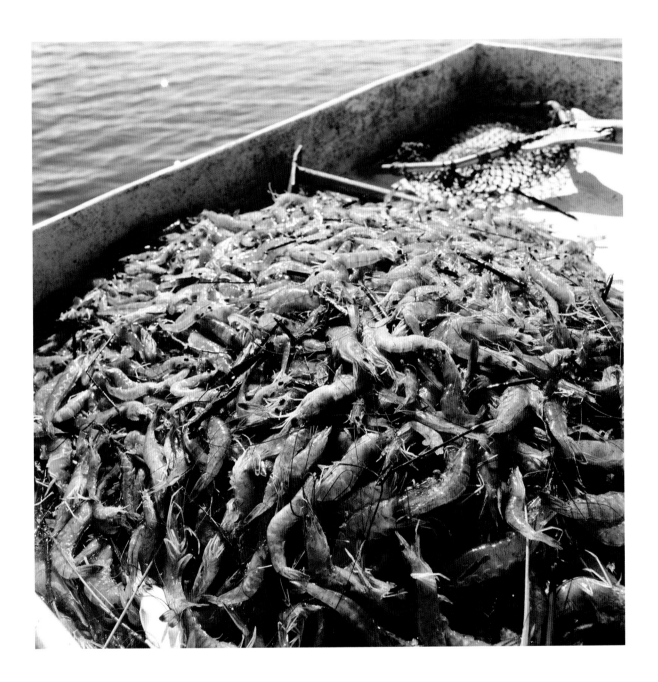

I love watching the dolphins.
I used to save the fish: The flounder,
squid, trout, and eel, they'd come
take the stuff right outcha hand.

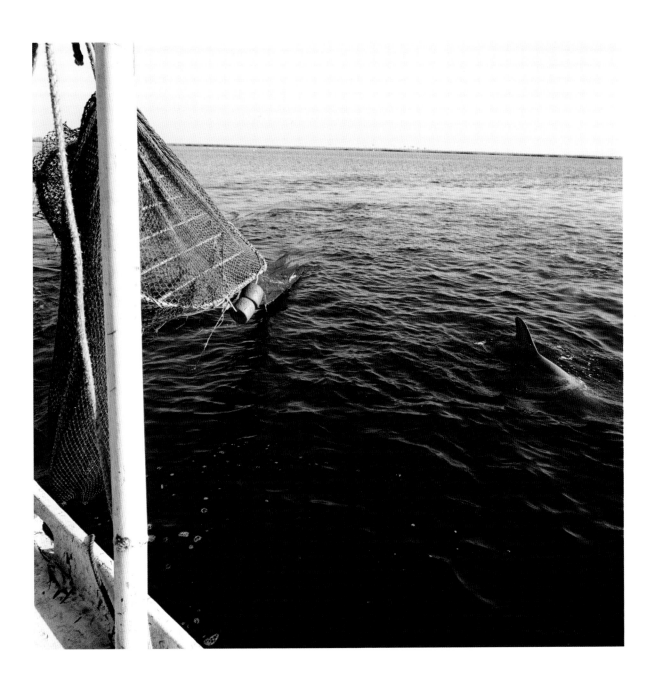

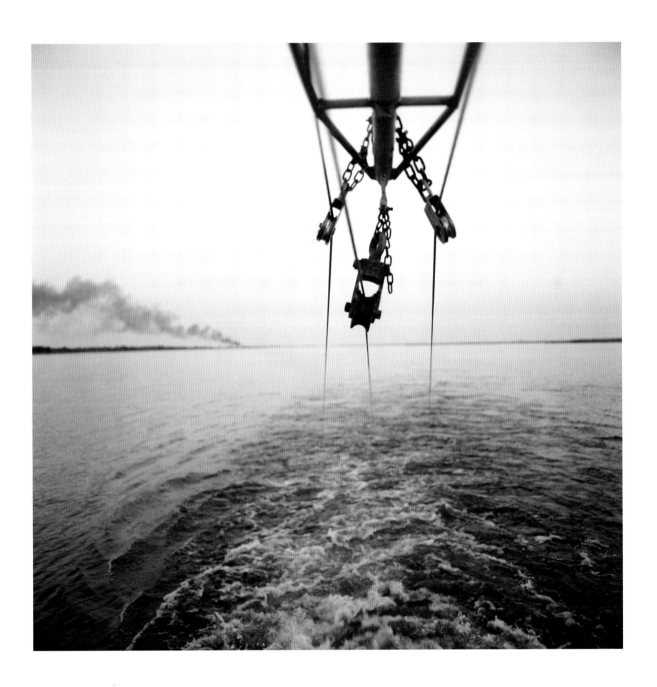

It used to be . . .
everybody wanted
the fish we had
down here.

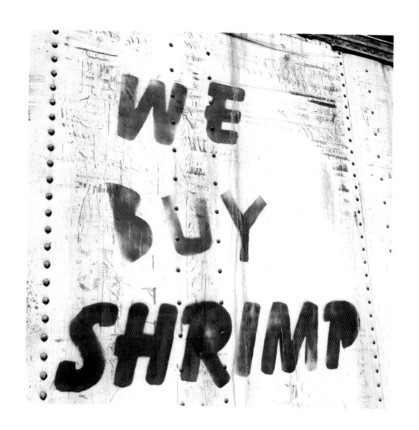

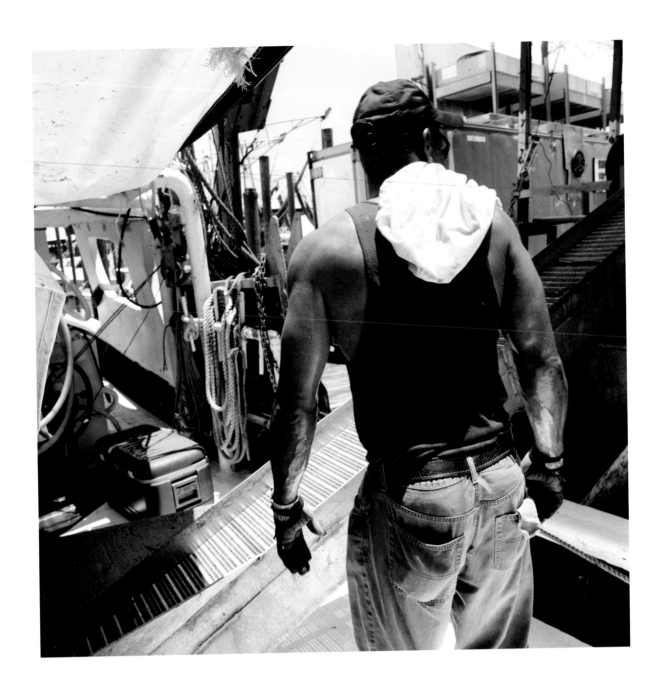

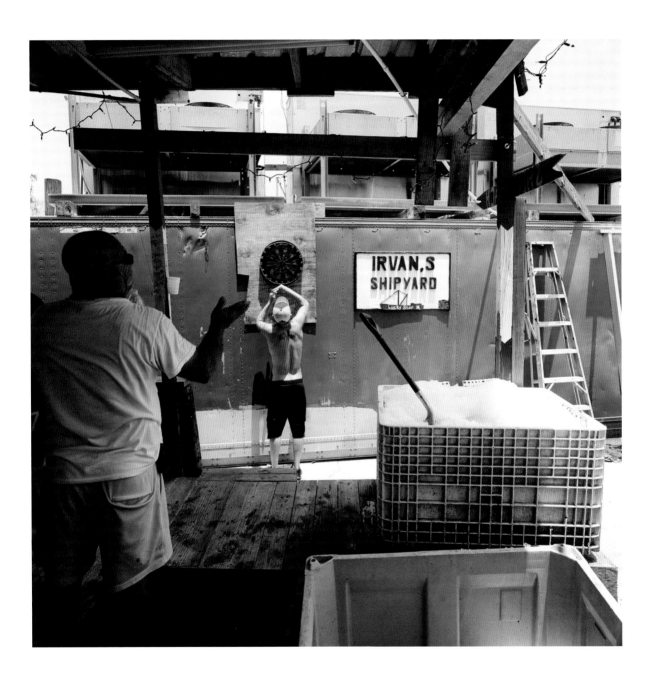

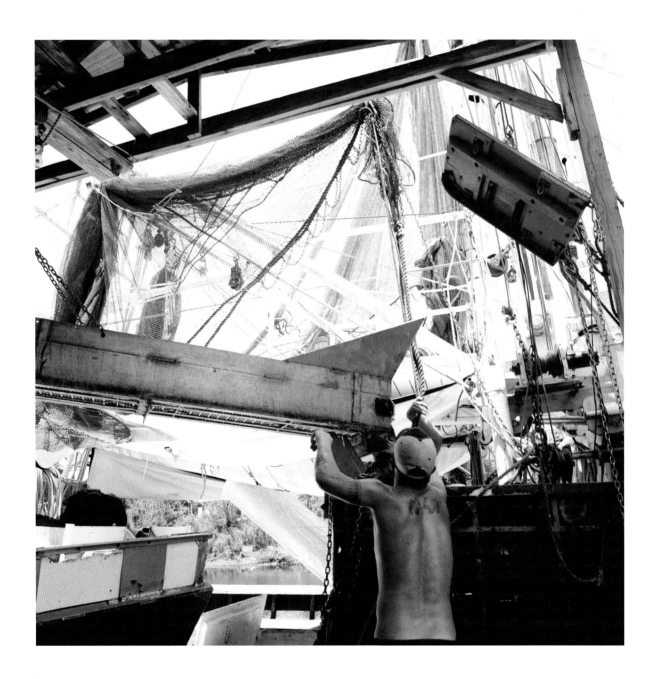

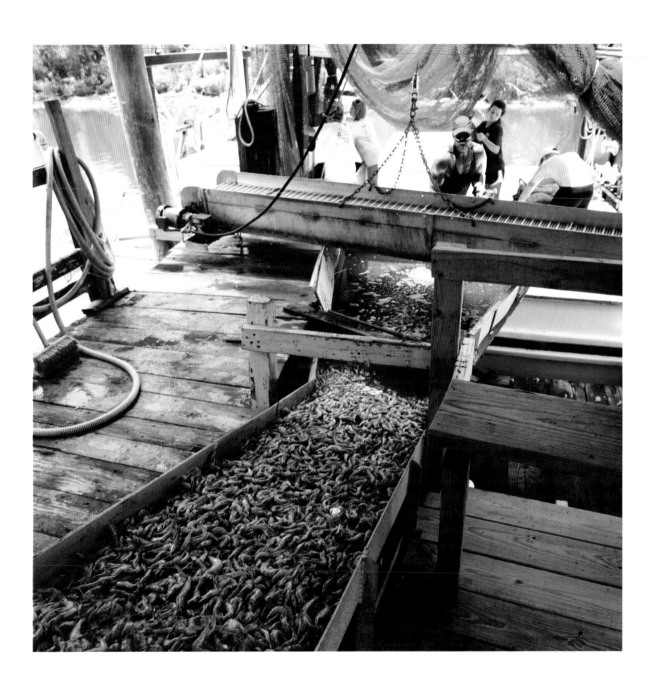

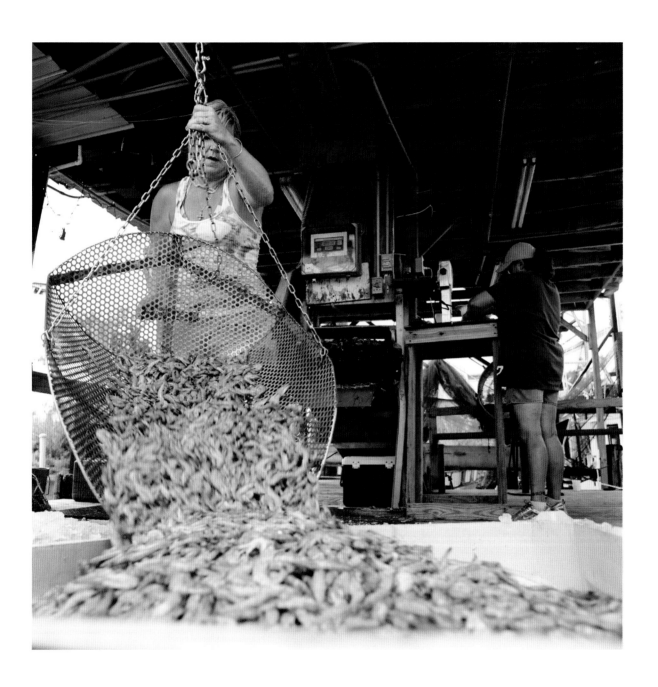

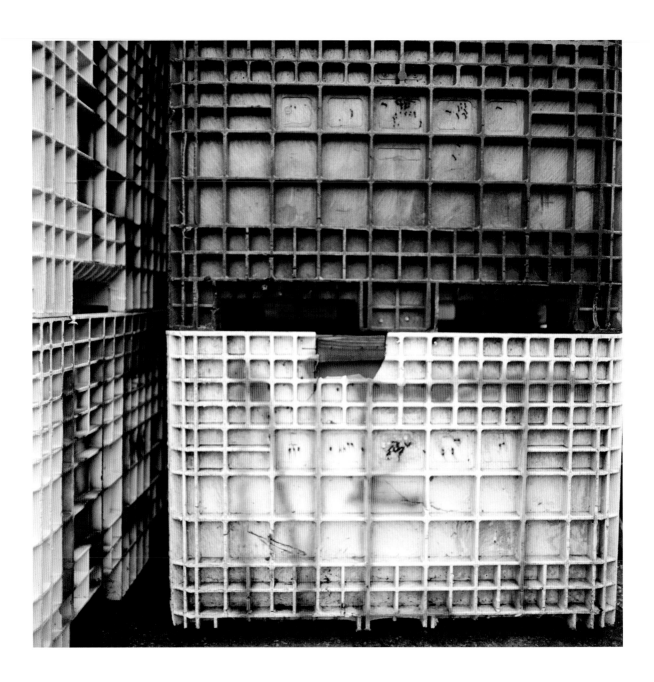

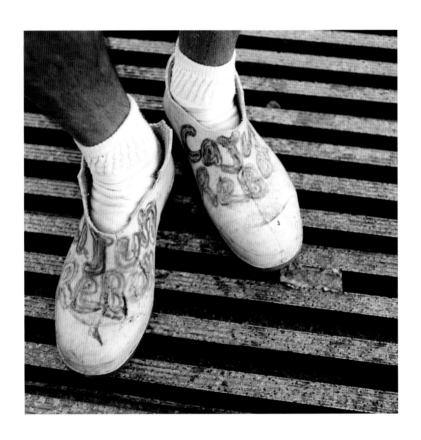

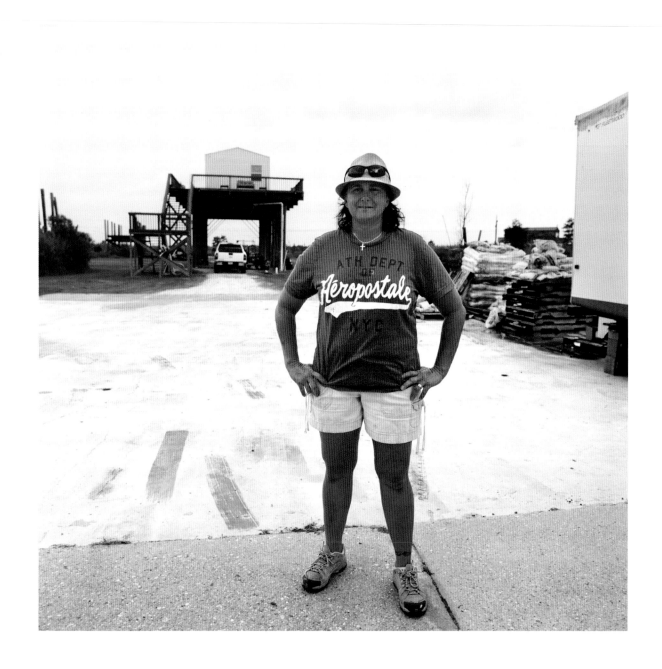

I quit school and went on a boat with my Dad.
Drove him nuts for twenty years. I tell you, though,
I miss those days, cuz how many people could
actually go work with their parents, you know?

You save the boat. You don't worry about your house. You save the boat. You save your boat, you can make a living, get your house back. That's how we was brought up.

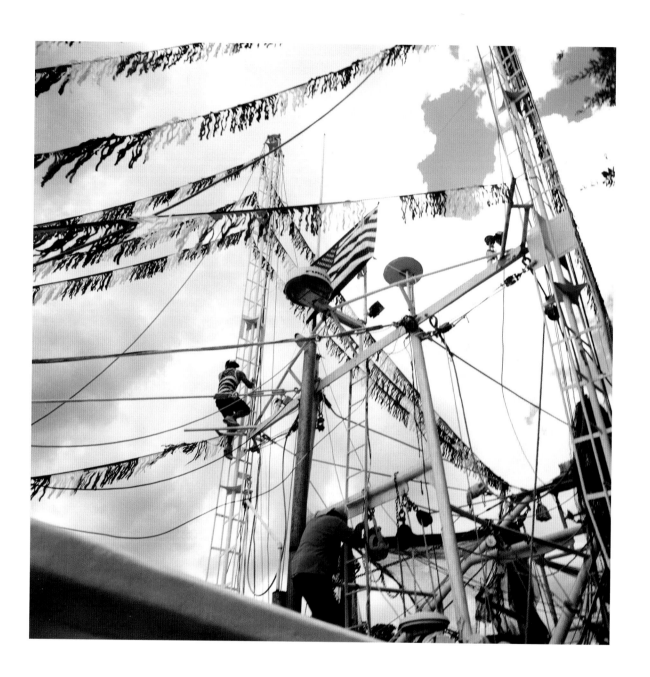

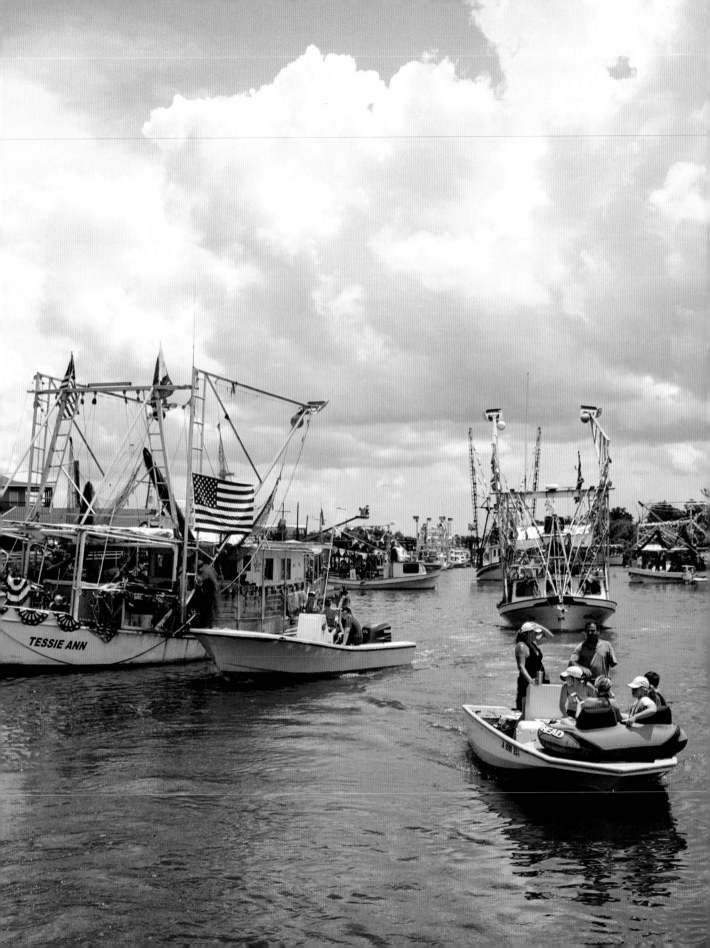

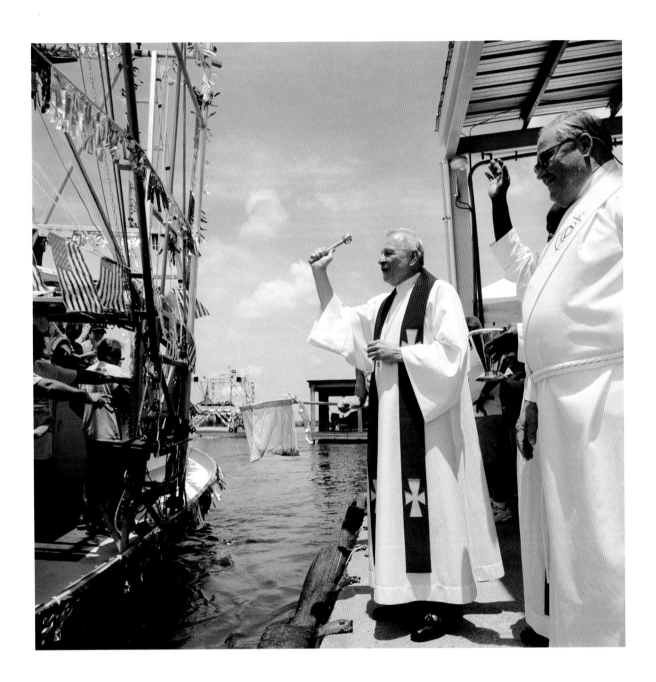

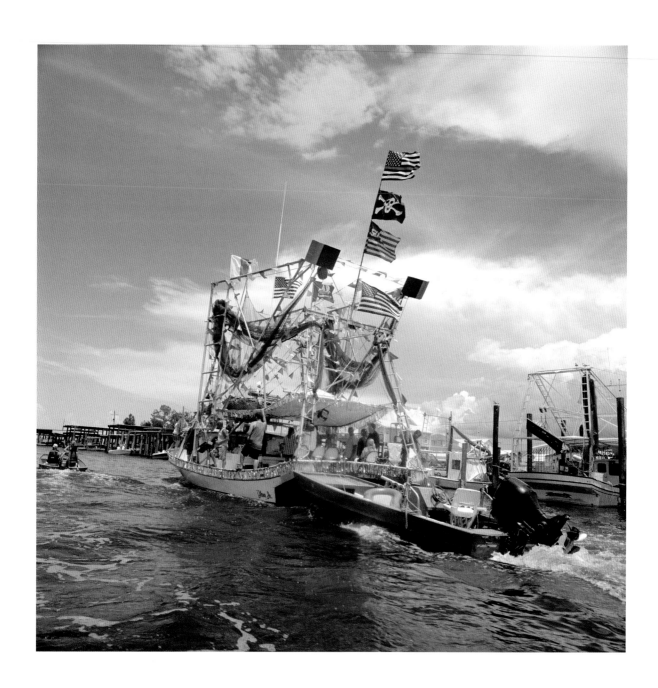

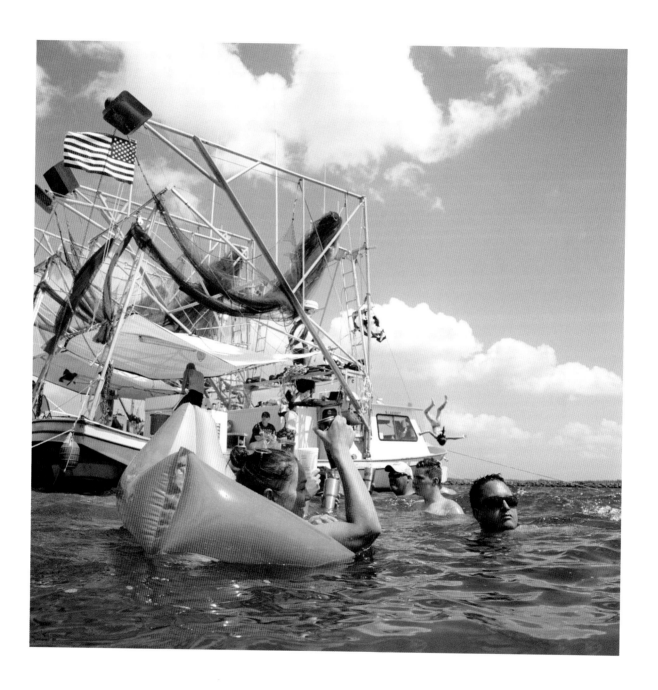

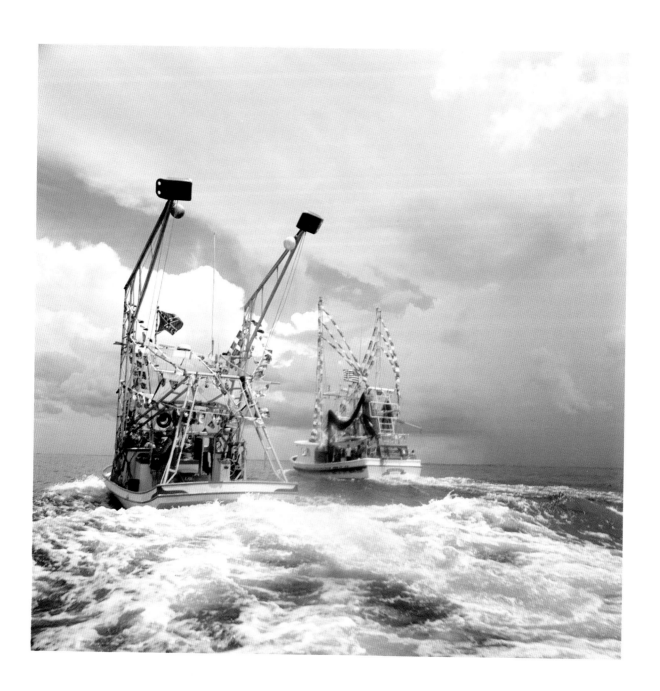

I was born right here on
this bayou; born and raised.
This was my playground.

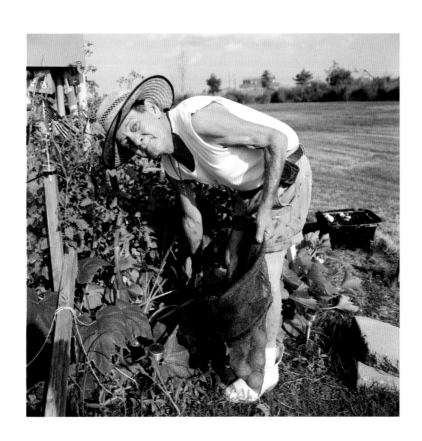

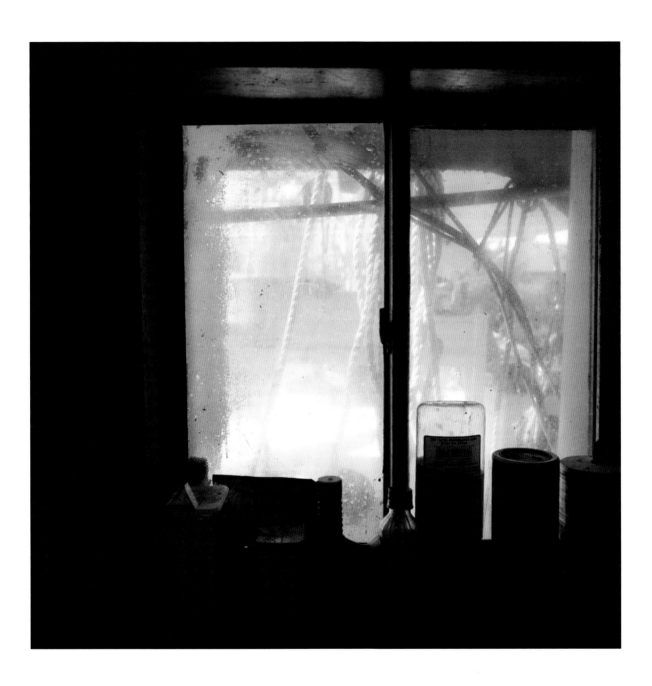

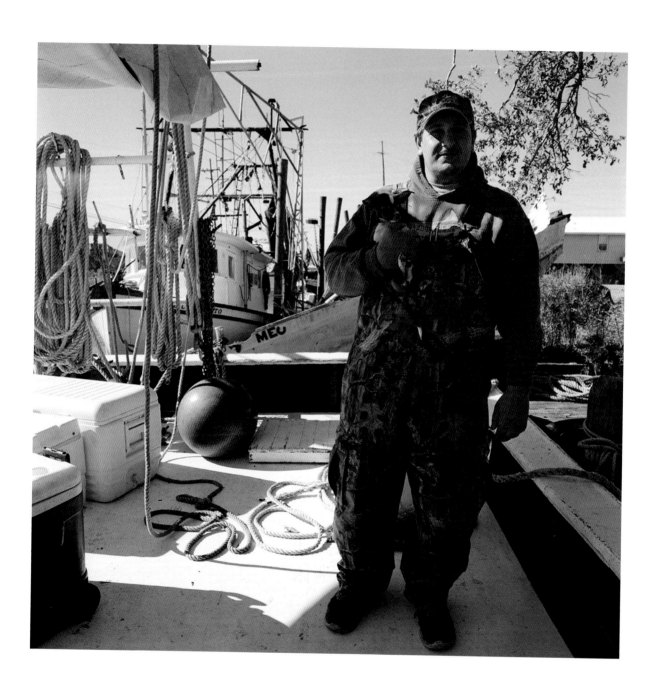

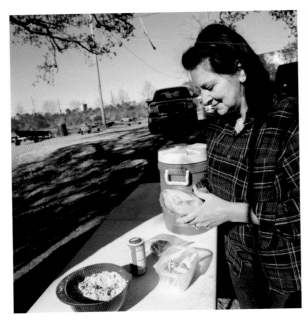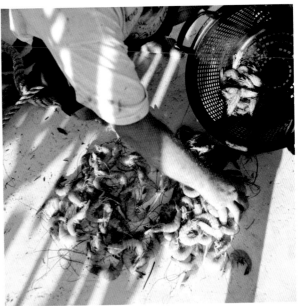

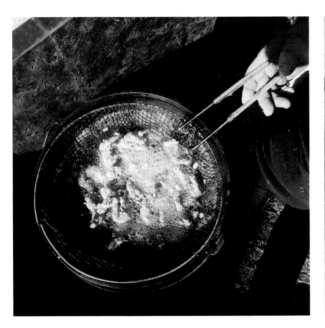

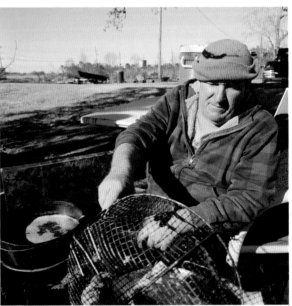

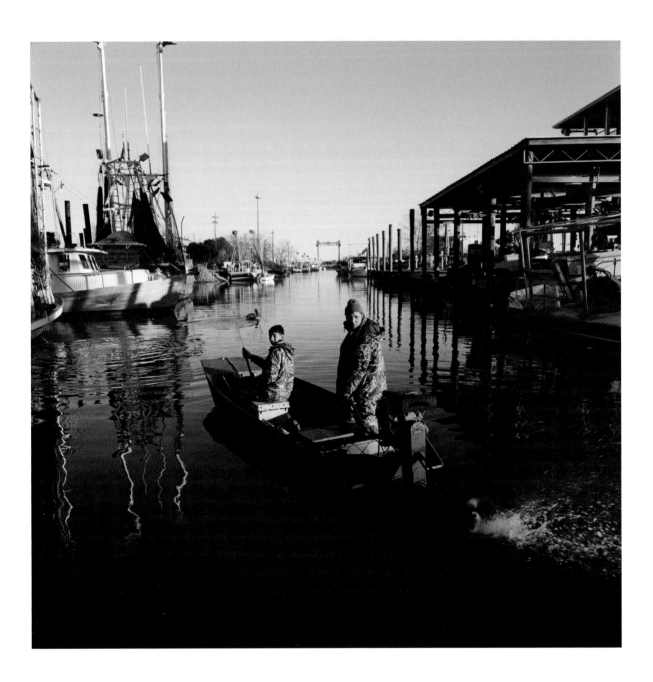

We go back to the 1780s. Our people were sent here
from the Canary Islands. When they got here, they
looked at the land; it was all marsh! But they saw
something else. They see what I see. This is heaven.
But I watched the marsh disappear in my lifetime.
When I was a kid, this was all freshwater. Now,
it's all saltwater. That was a ridge of trees.
That was all oaks. Beautiful, it was beautiful.

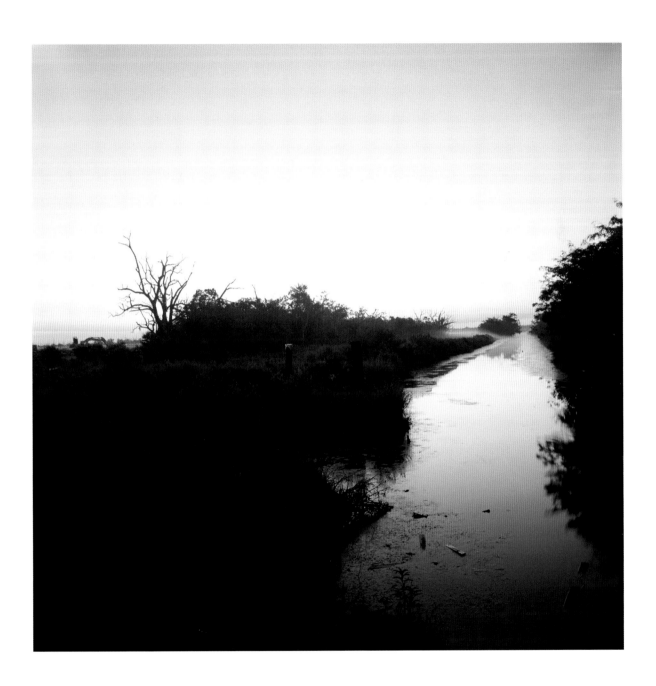

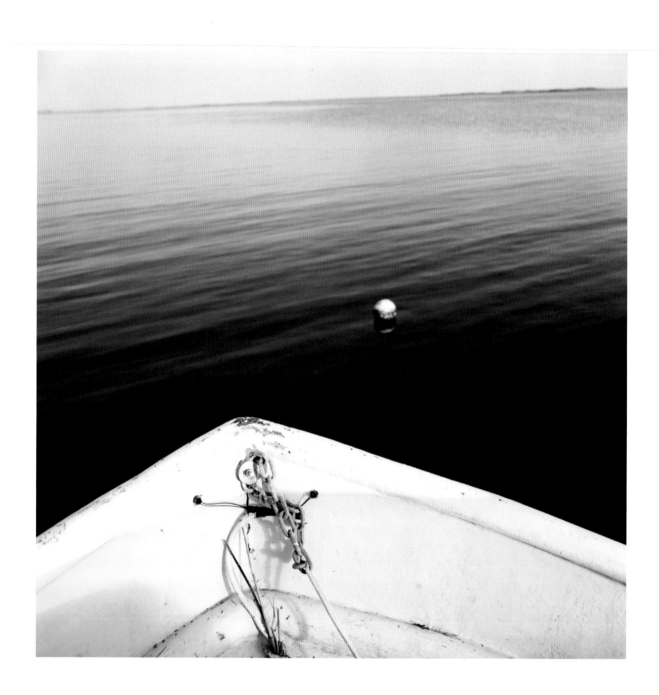

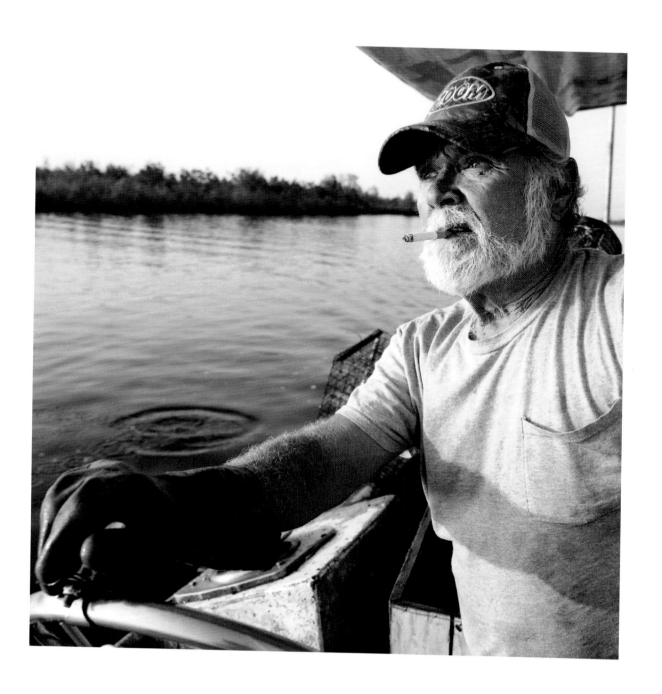

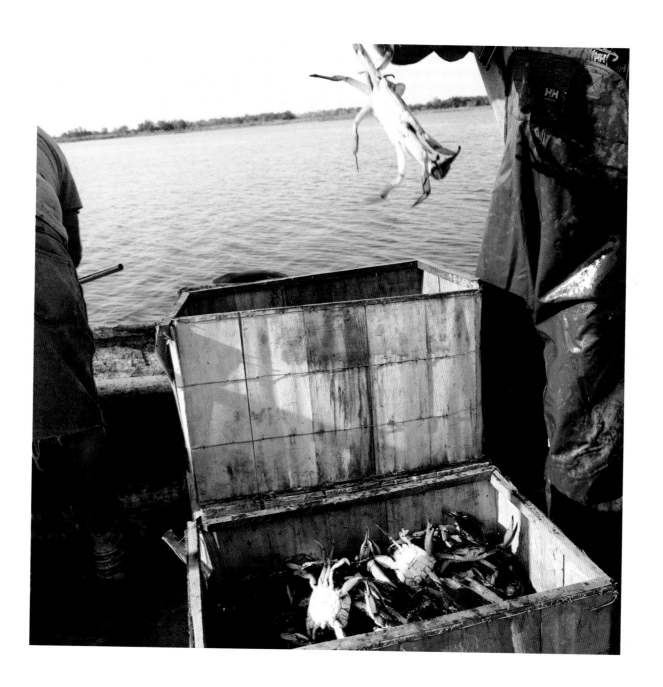

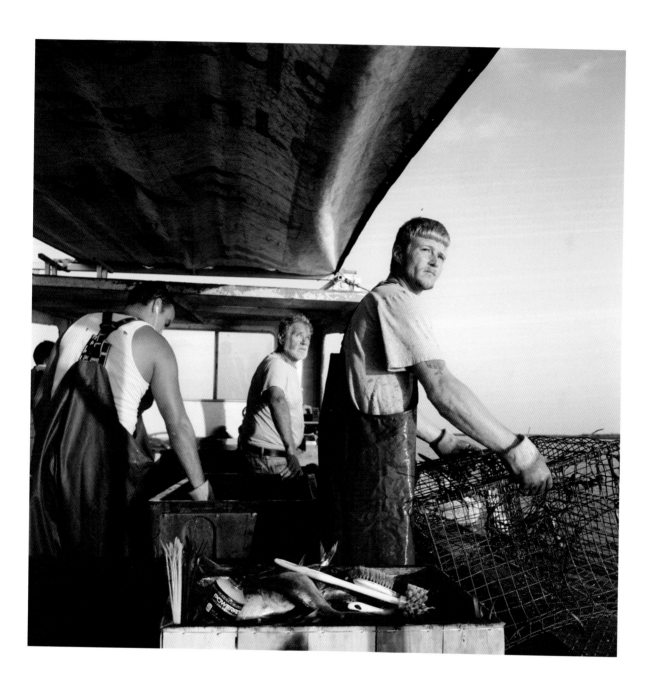

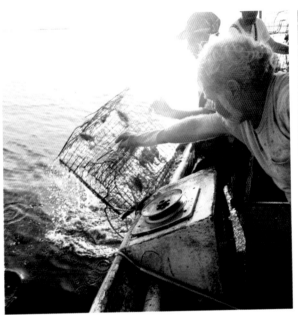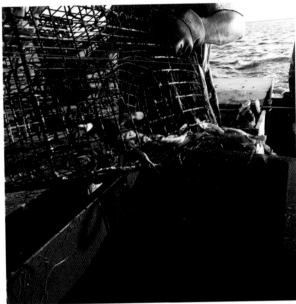

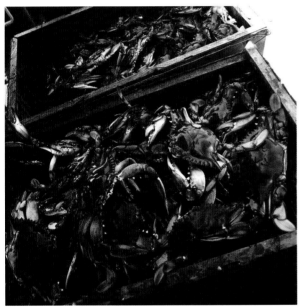

99

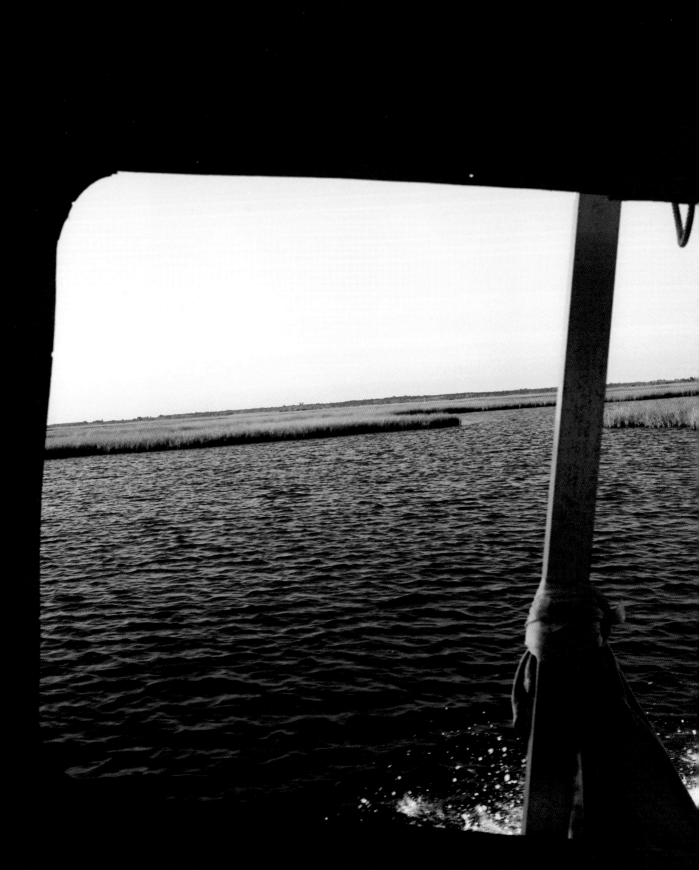

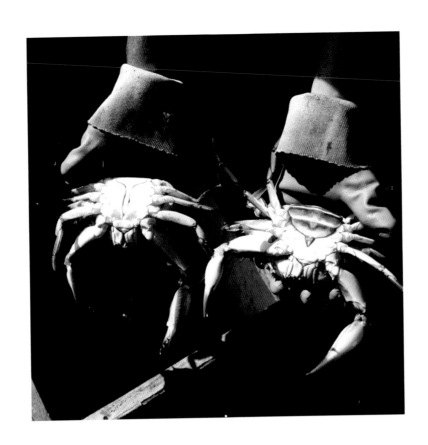

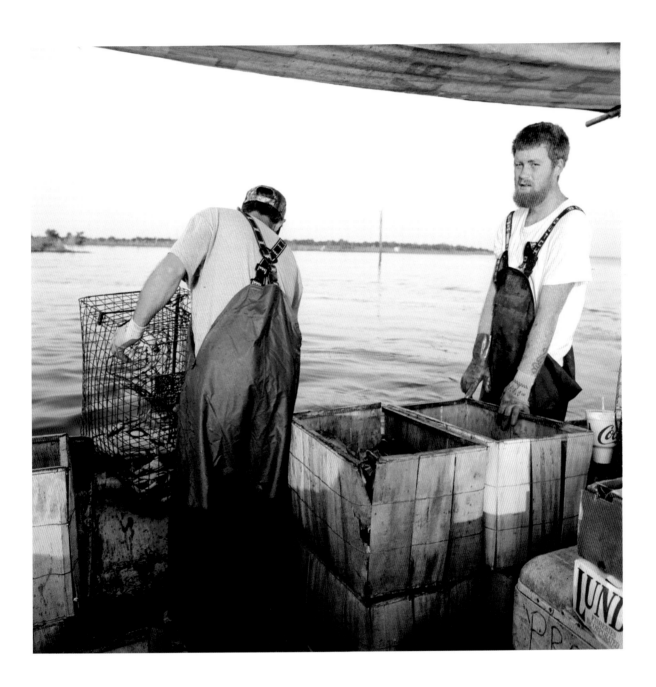

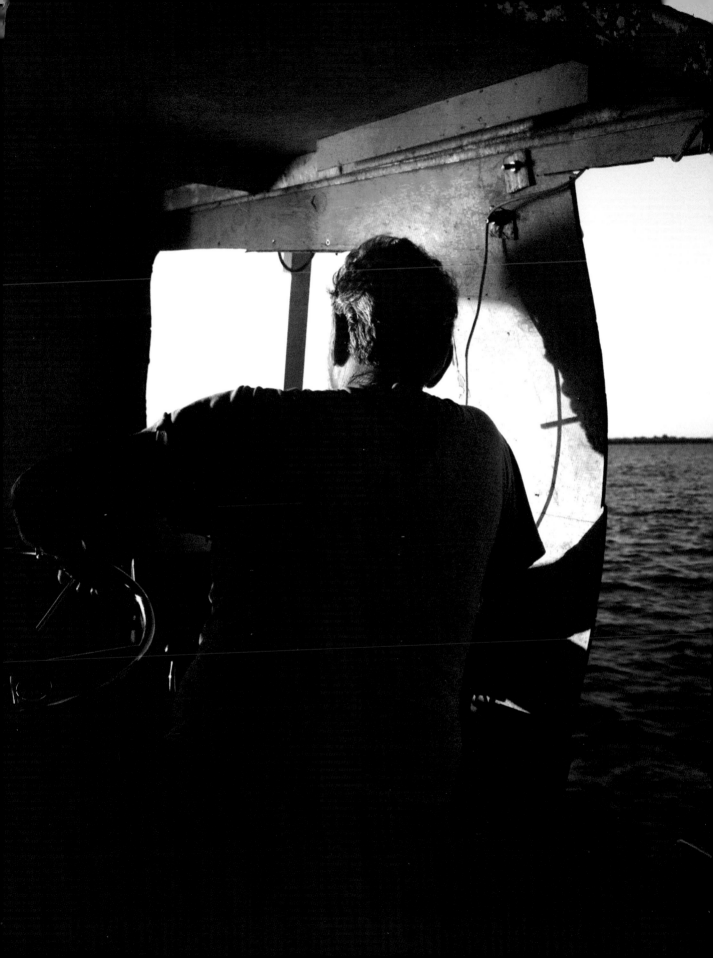

Whenever a man can go out and don't have nobody to answer to but his wife, you got the freedom to go out and make a livin' and come back in and feed your family. That's all the pride you need.

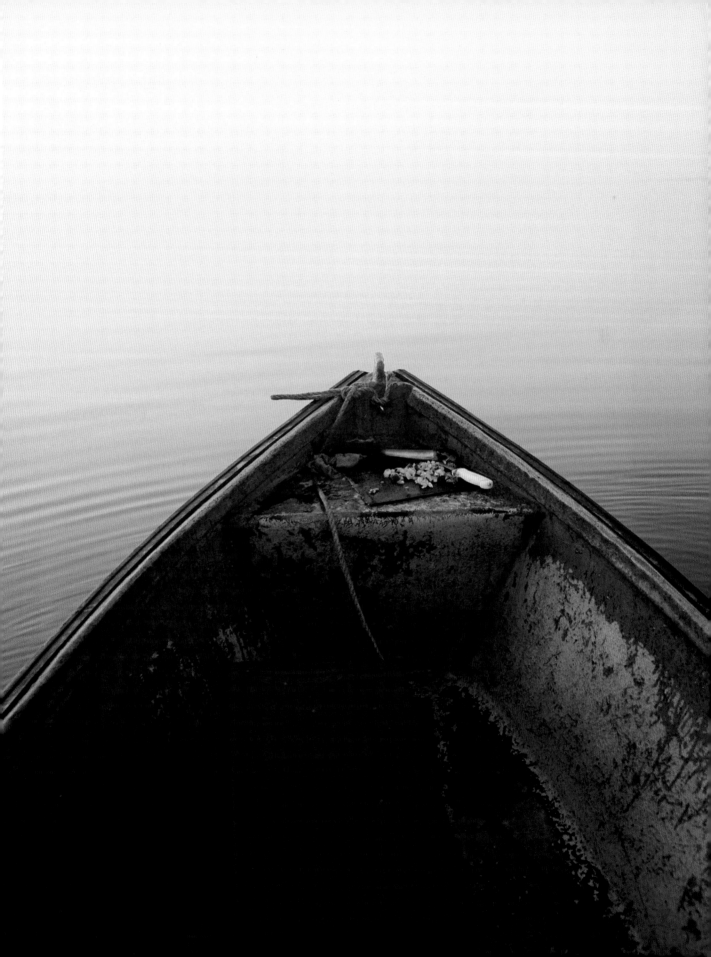

I just love bein' on the boat.
Get up early, see the sun
go up, and you can see
the sun go down.

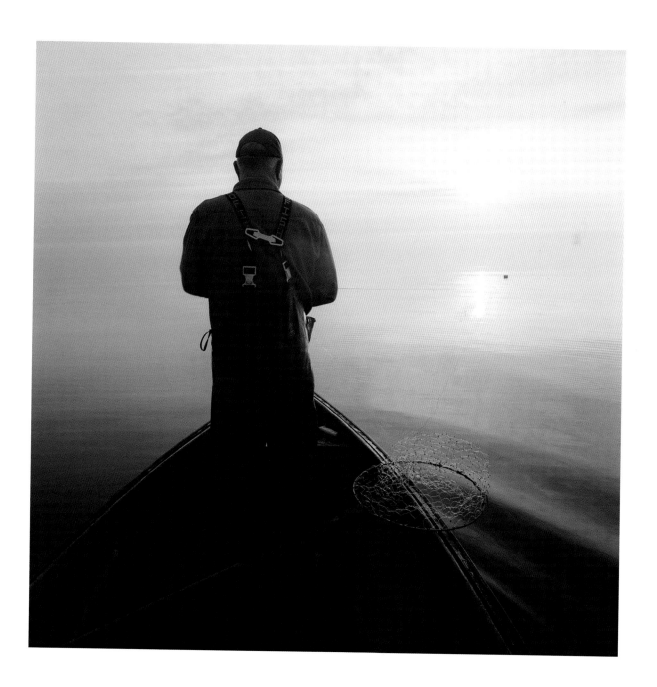

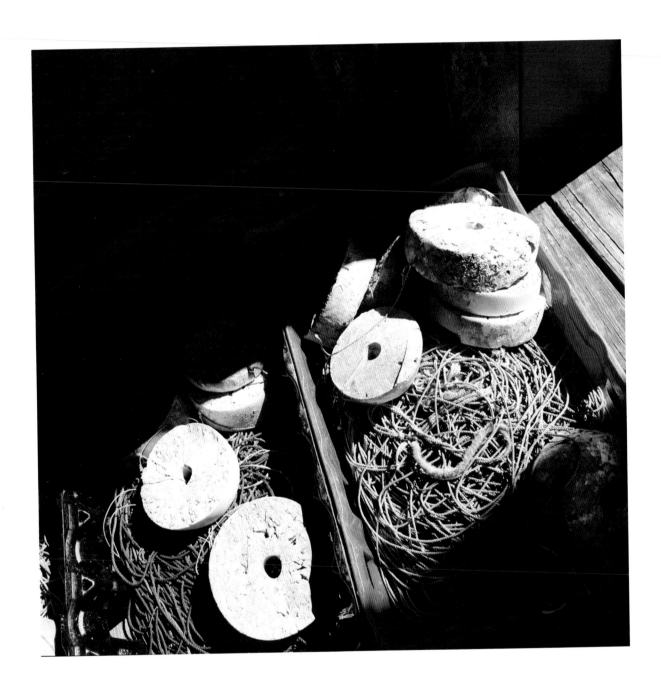

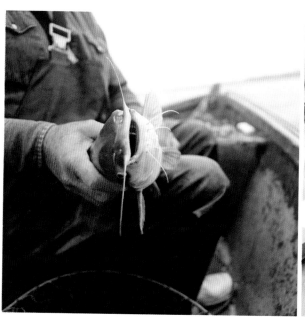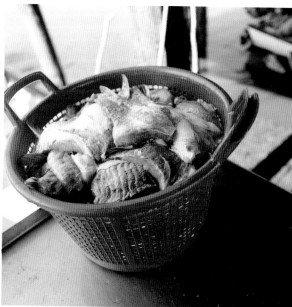

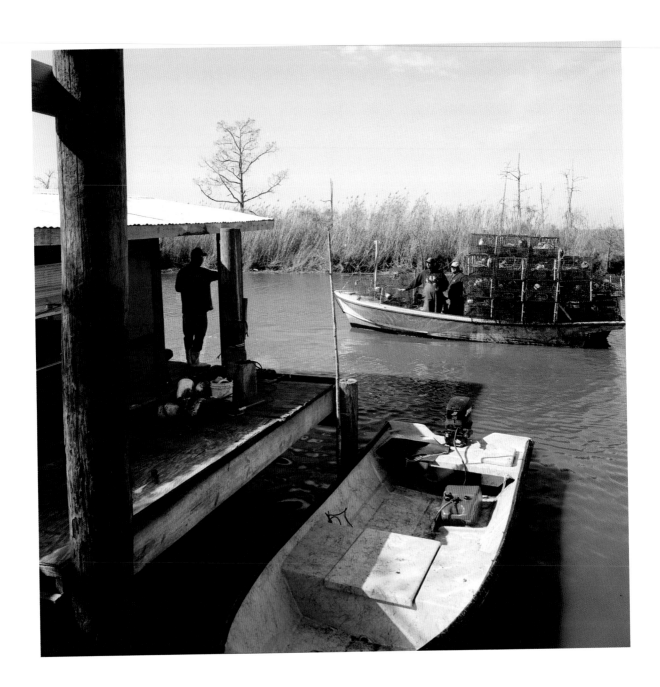

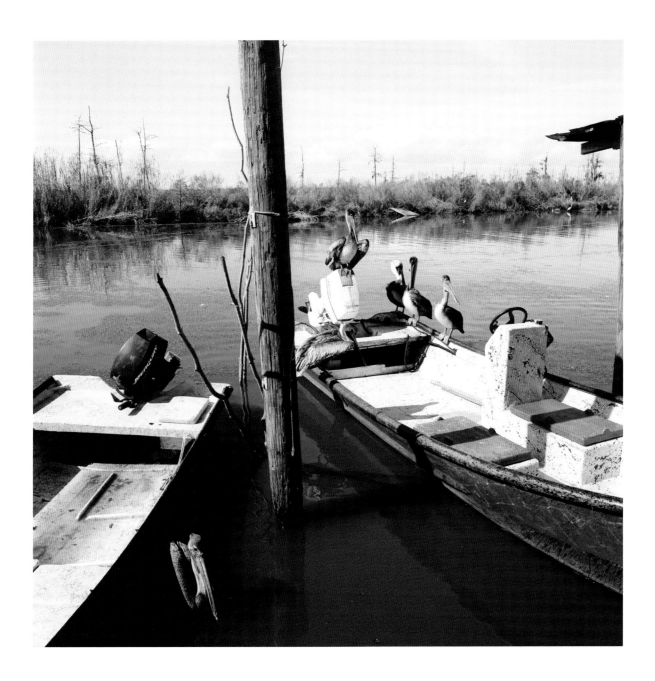

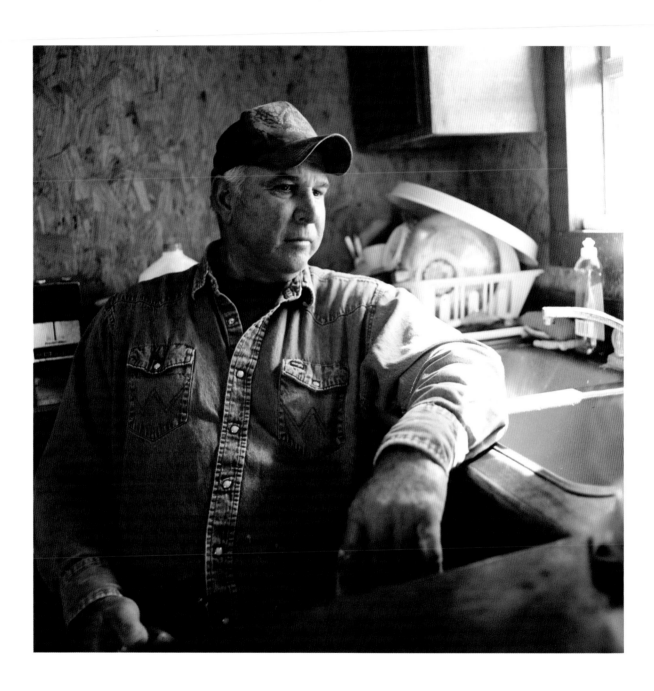

My mother's family came from Maupas, a barrier
island in Louisiana, and her family moved here before
the highway was here. They come across in a boat,
went down through the south pass on Lake Pontchar-
train, and they lived on a houseboat. All they done
was trap, fish, crab, pick moss. Everything they got
they either caught or killed it, or if they caught or
killed it, they'd eat it. They fished for a living. Mama
done it all. She would bring me by the hand in
the swamp, and we'd put traps out, catch coons,
then the nutrias, and we'd go fishin' down the pass,
and we'd run lines. She'd do all that with me.

I had my camp; you had to get to me by boat.
You'd go two blocks up the bayou, and there
I was, right there. Furthest you had to go was
two blocks up the bayou, and Katrina demolished
that. It was one hell of a place. We'd usually
catch fish off the dock at night, all the time
underneath the light. That's Black there; she's
dead now. She would pick all the fish up when
you threw 'em down on the dock. Picked up
the fish, put the ice chest up, open it with her
nose, and drop the fish in for you.

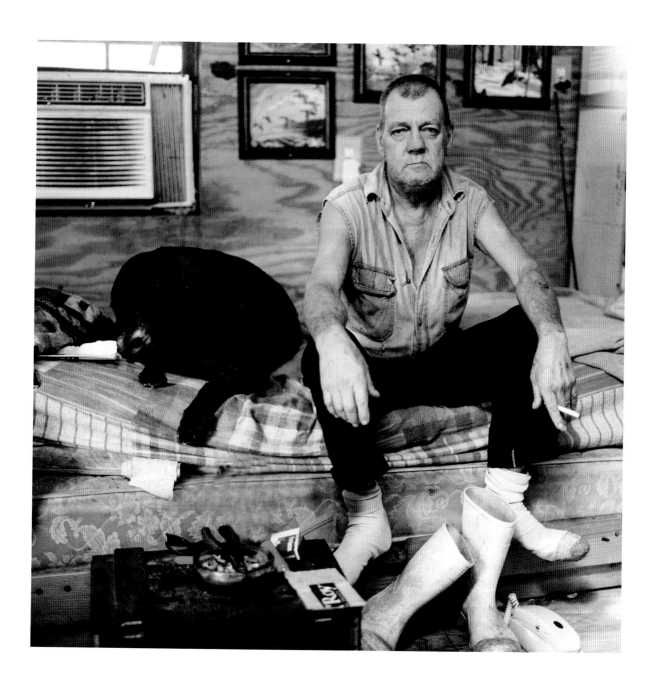

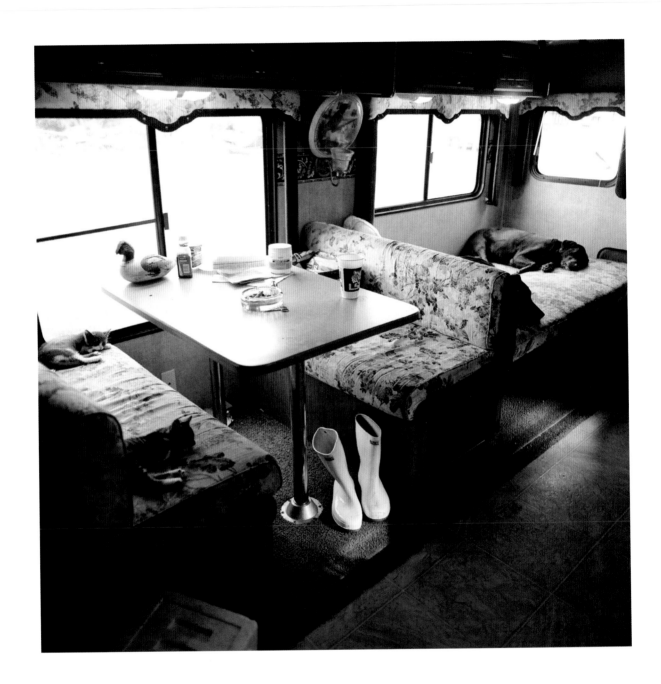

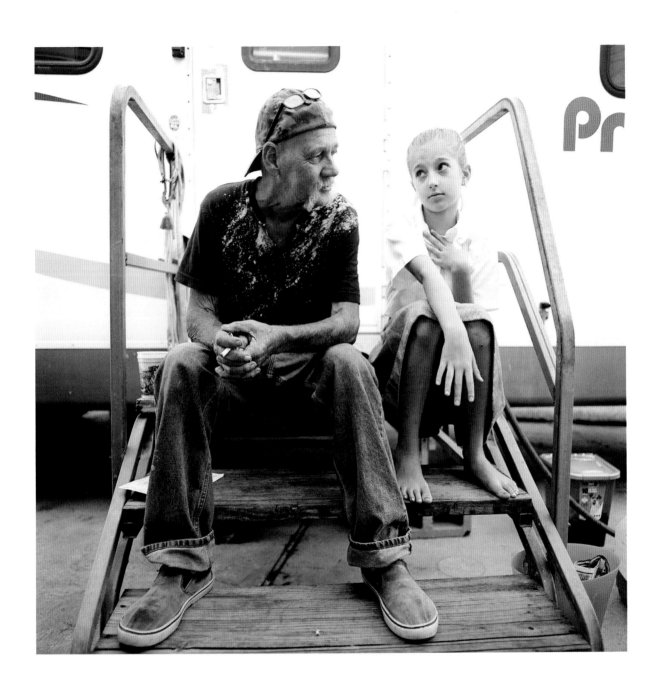

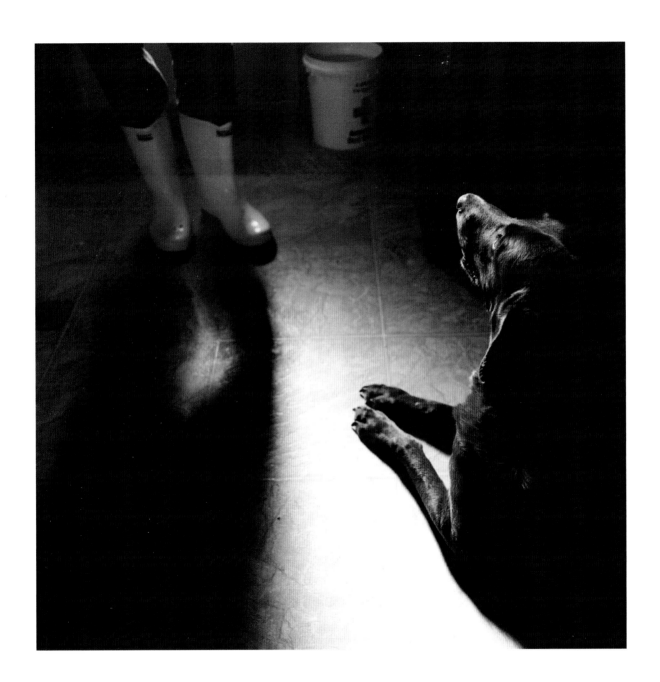

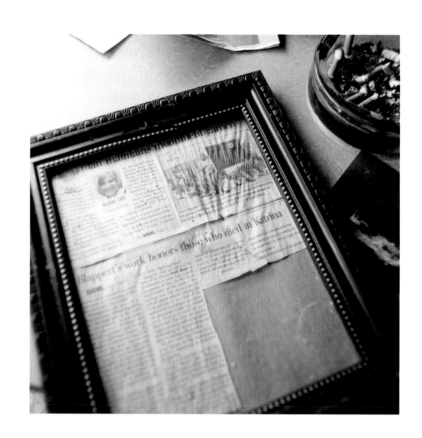

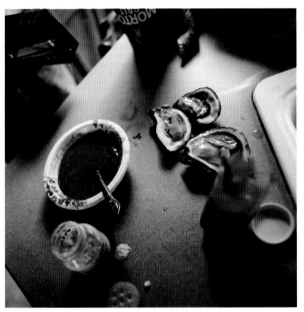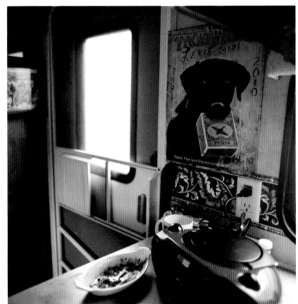

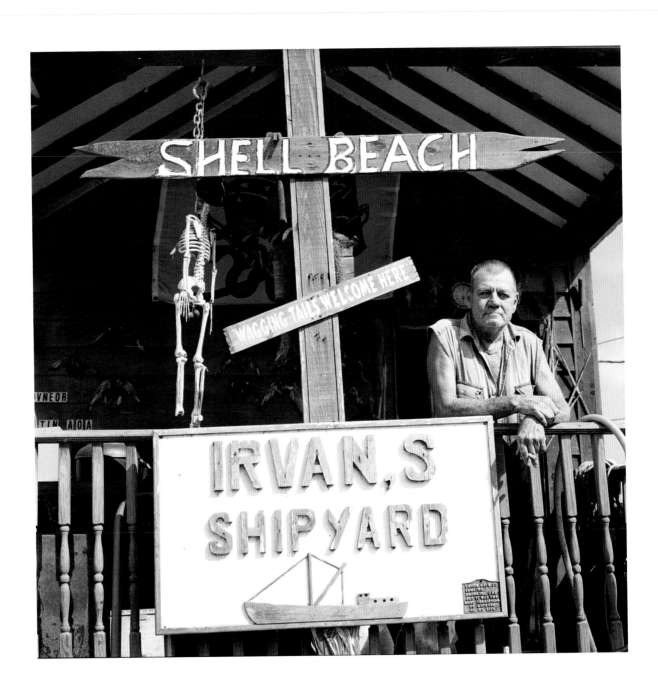

I decided to stay for the hurricane. Should have went with my better instincts. Twenty-four hours I was in the hurricane, and then, two o'clock the next day, I said, "I ain't gonna make it through the night—I'm gonna die when it gets dark tonight." Because I knew hypothermia was settin' in. I already accepted that I was gonna die. I went and sat on the bottom steps, so when I did, I'd fall in the bayou. I said at least I'll give back to the shrimp and crabs I ate all my life. I'll fall in the bayou, I'll feed 'em back something.

I got a picture of this bayou here;
I could count fifty boats from here
to Shell Beach. You know how many
boats I can count now? I could pro-
bably count it on my two hands.

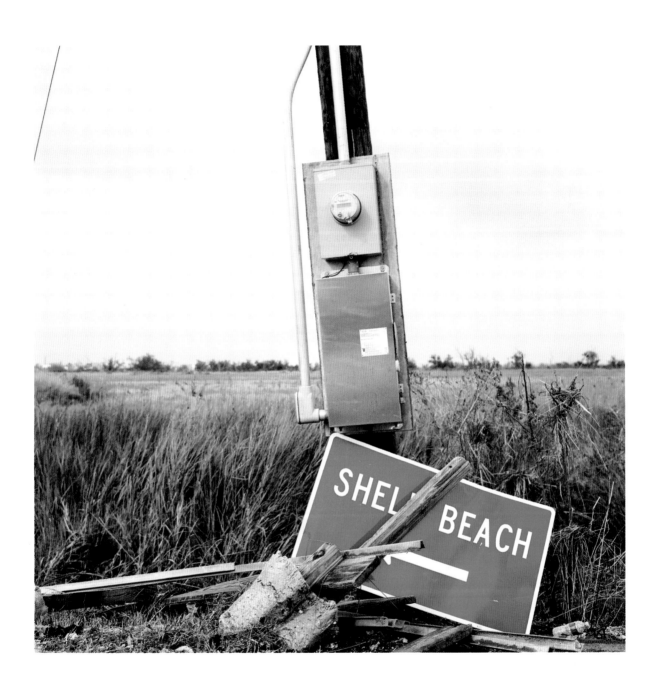

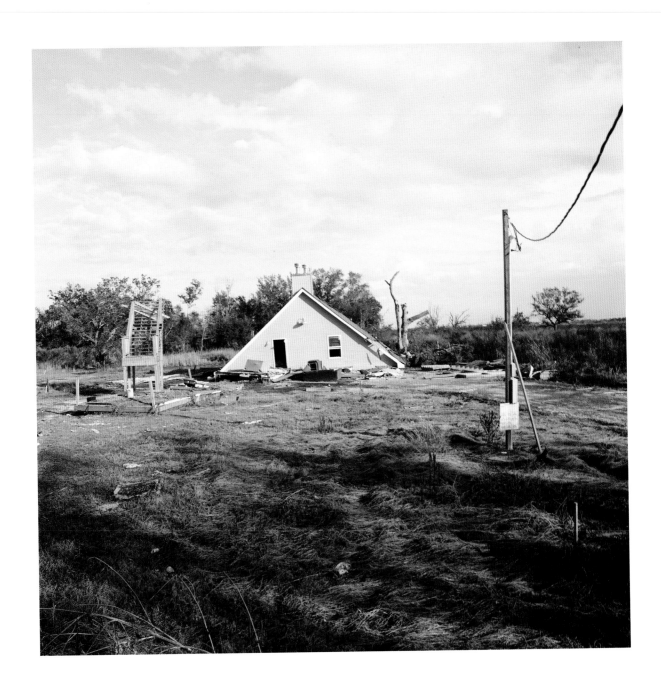

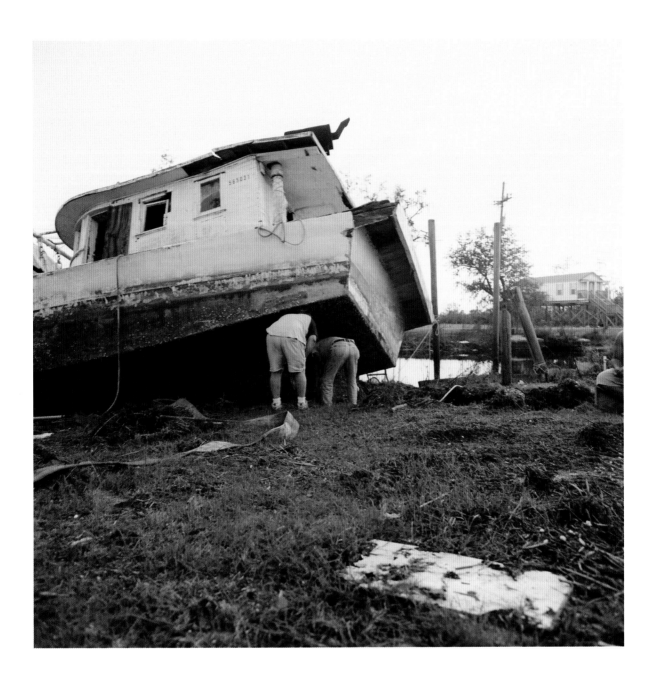

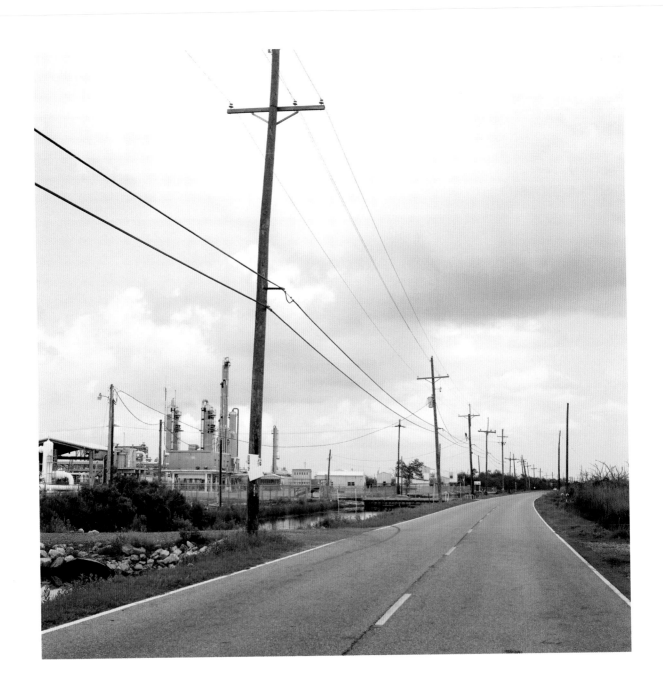

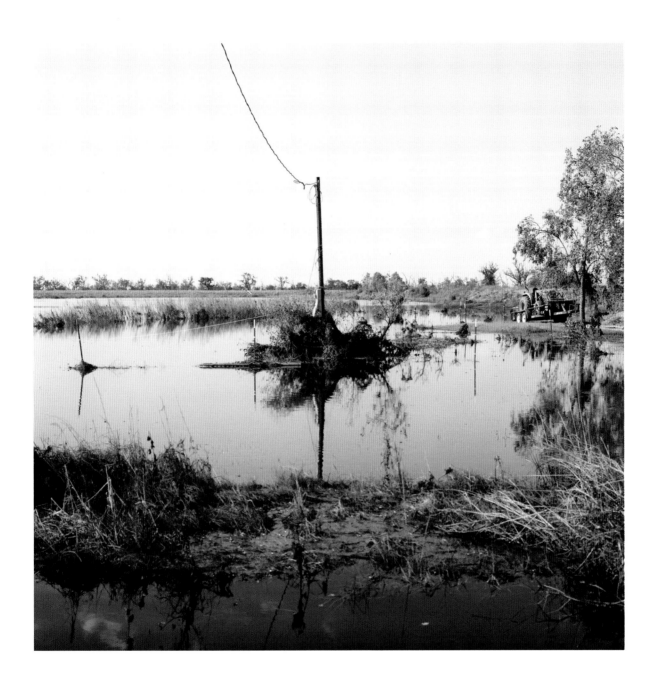

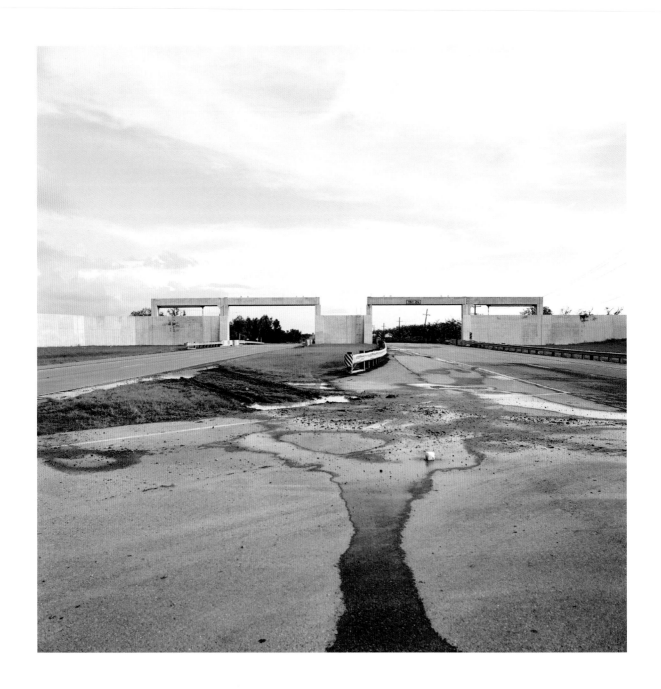

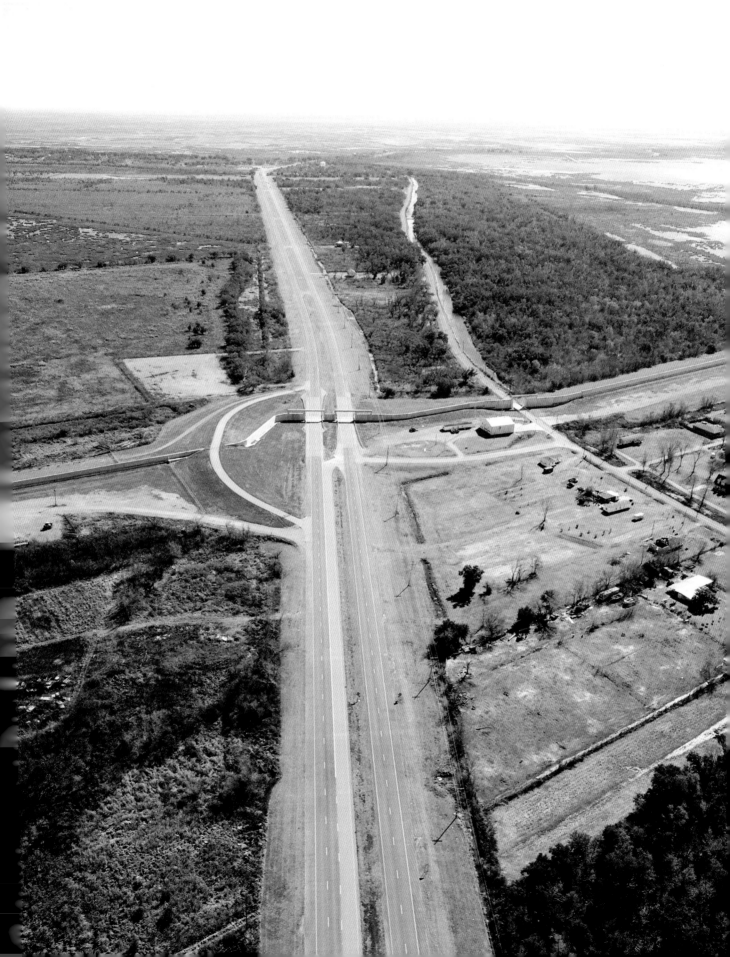

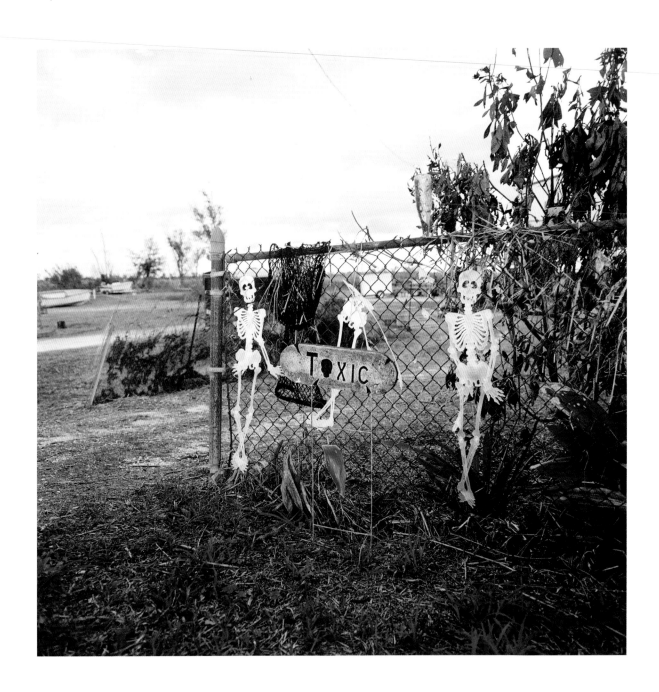

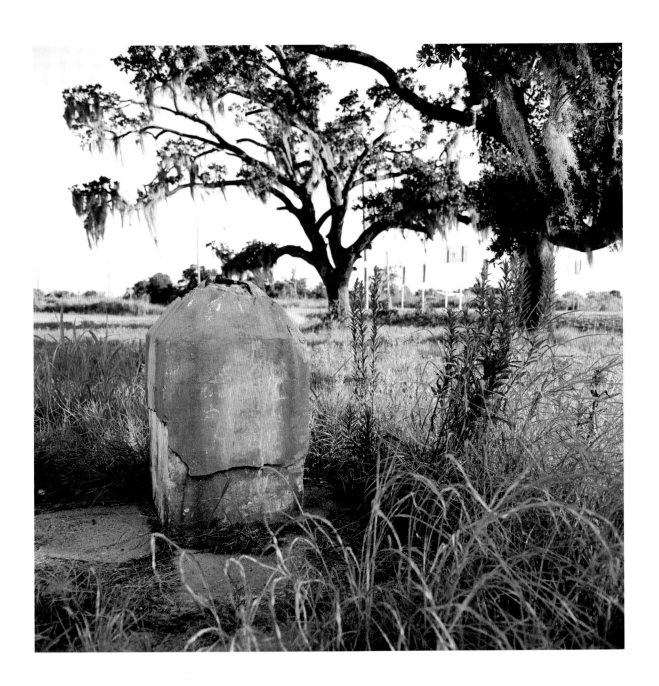

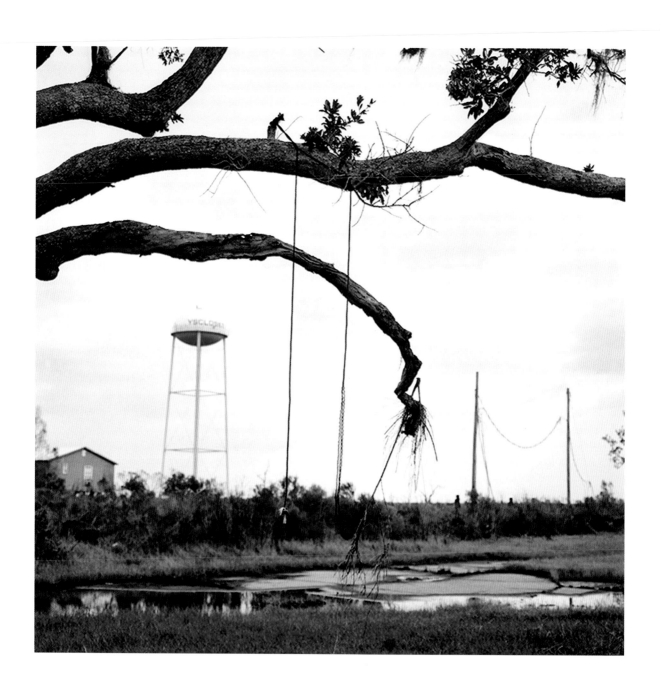

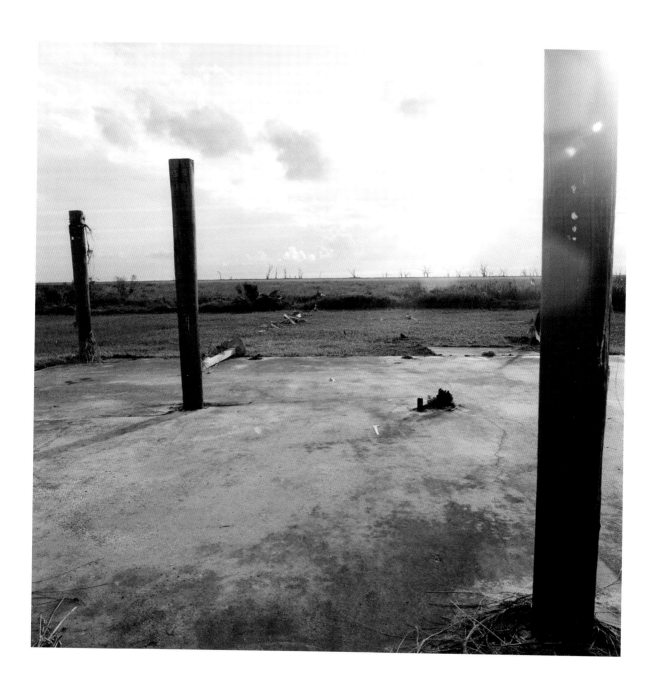

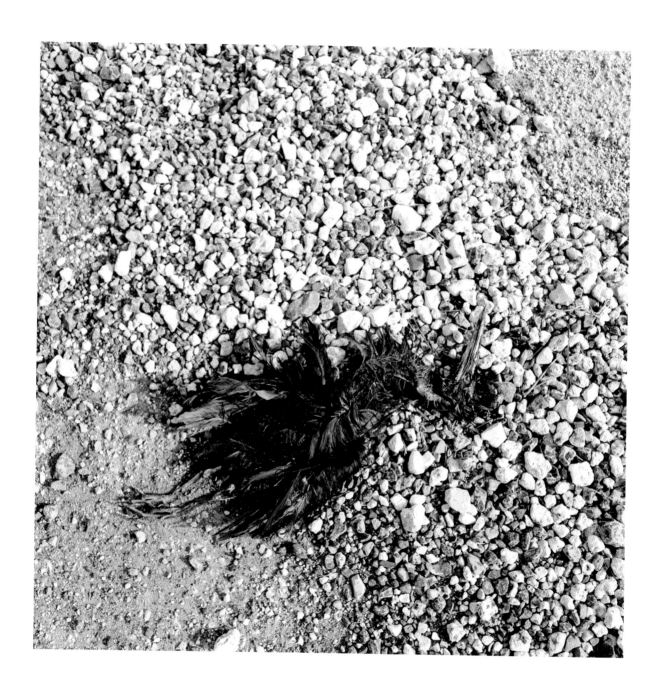

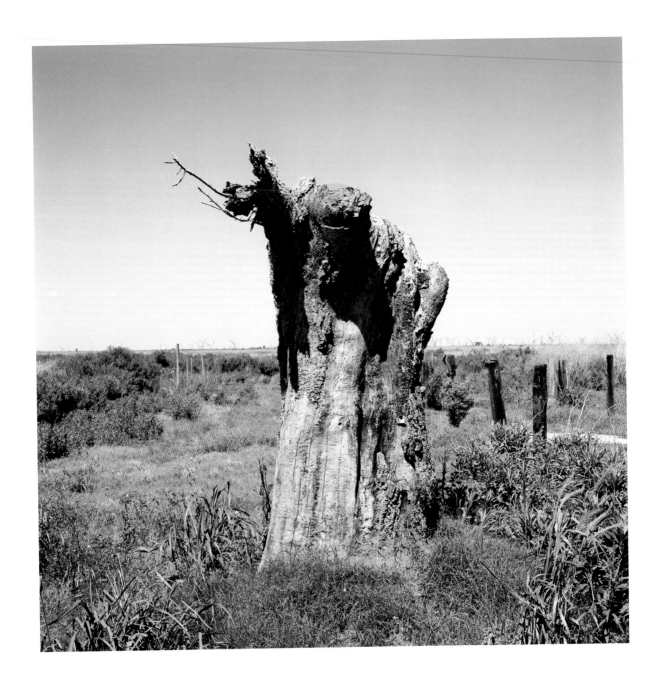

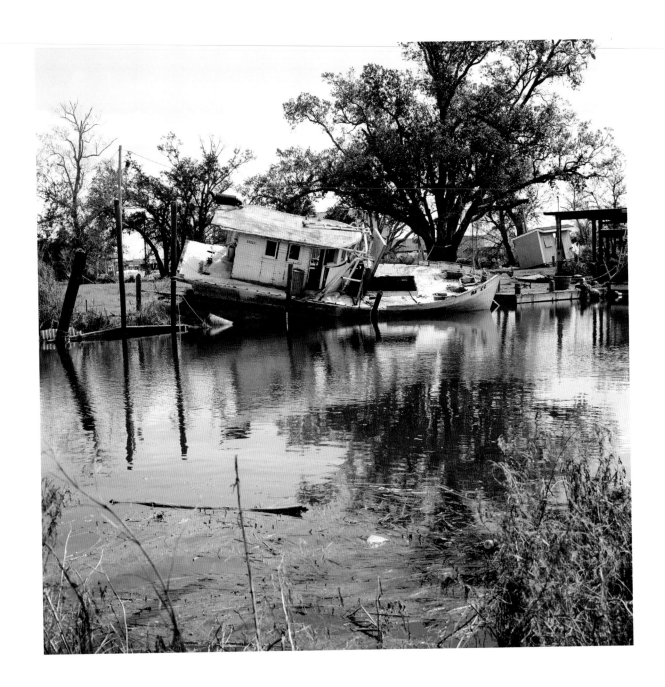

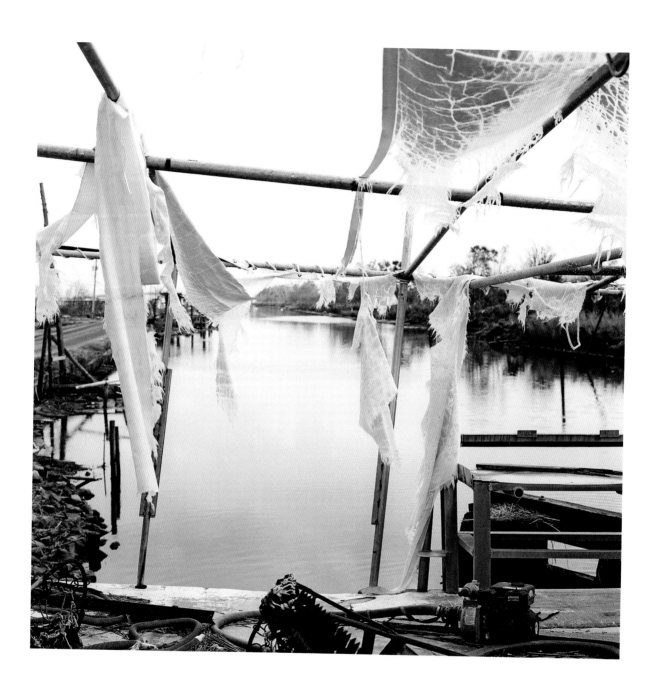

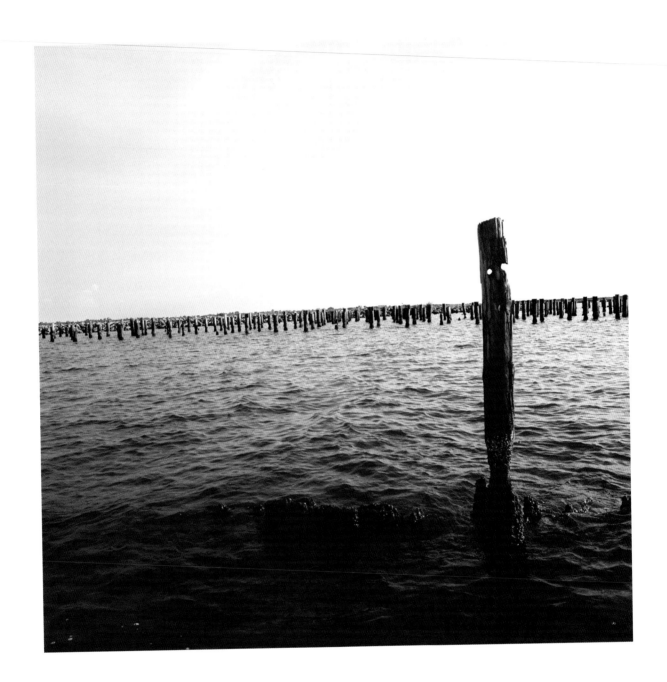

These swamps, as you look across the bridge, you see nothing, no trees. When I was a kid, that swamp was beautiful. The pass was loaded down with cypress trees and gum trees, and you used to hunt for squirrels along the pass back then. Now, a squirrel would have to pack a lunch just to find a tree to get in.

My Daddy built them boats, and he was proud
of that. He was proud of his culture. I'm proud
of it, too. I'm just like my Daddy. I know who
I am. I can tell you who I am and where I come
from, and as long as I know that, I'm OK.

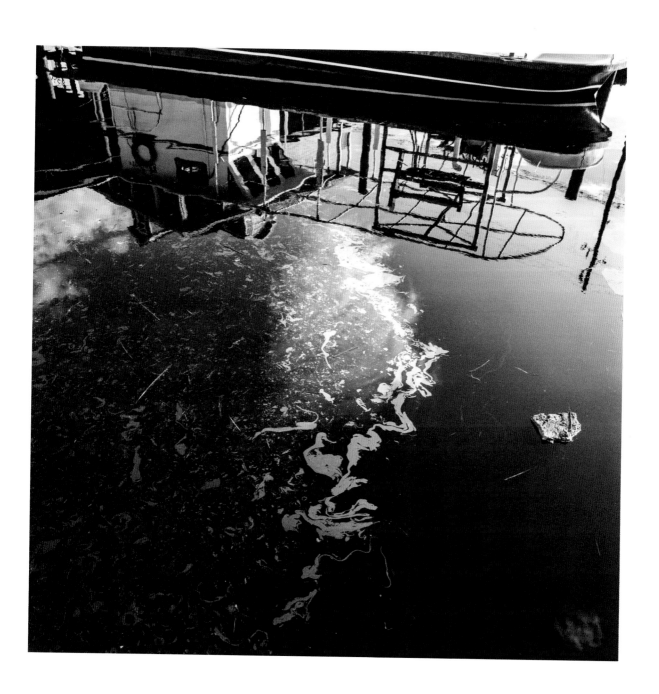

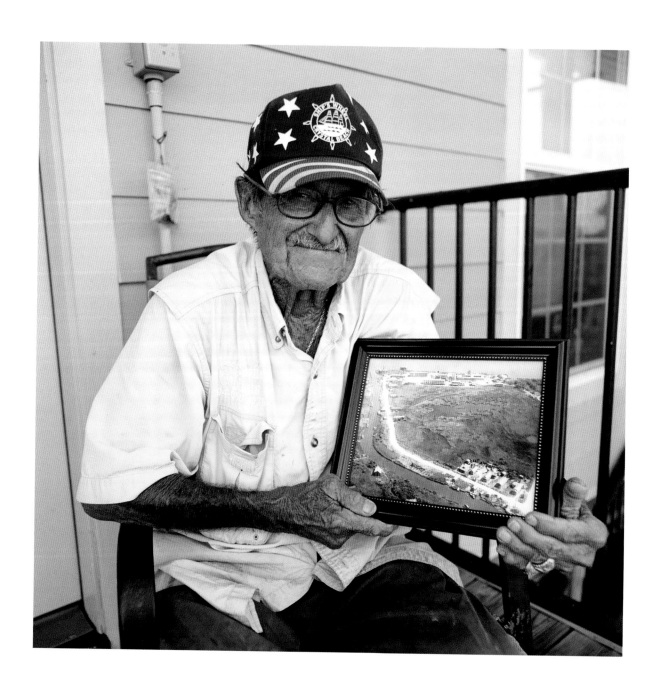

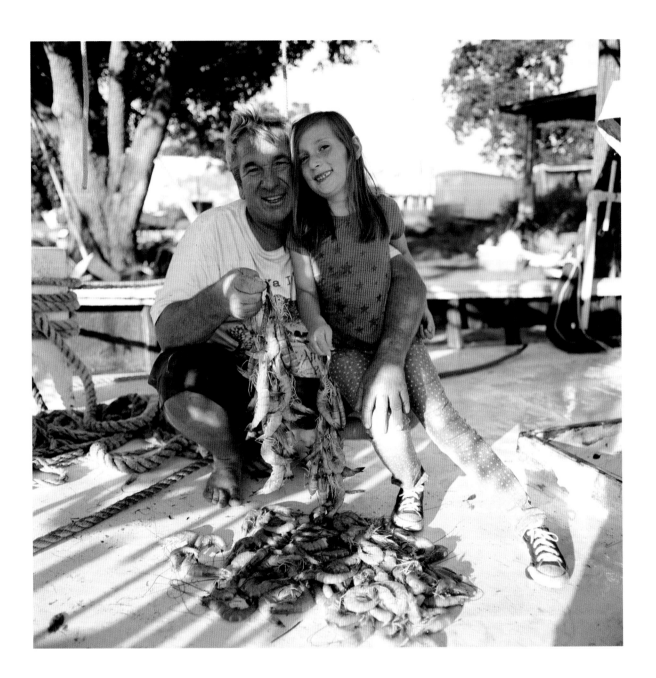

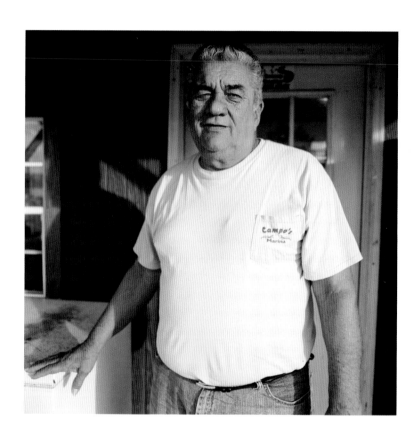

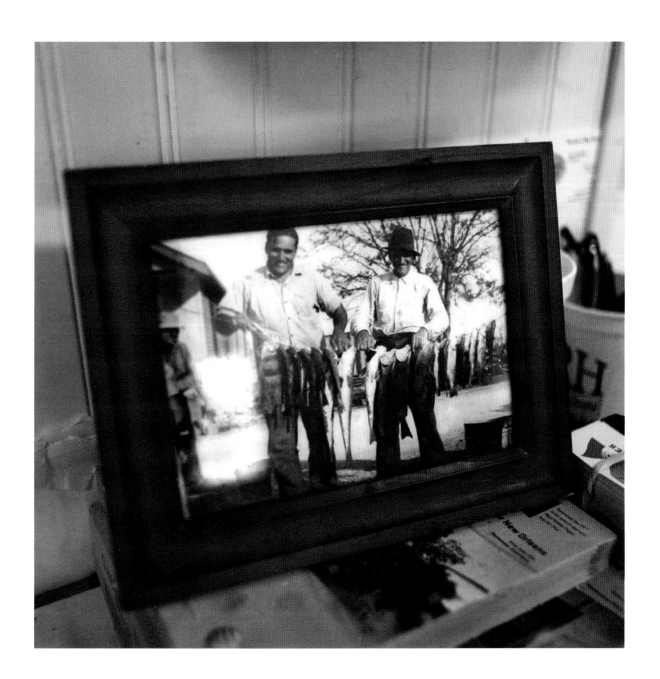

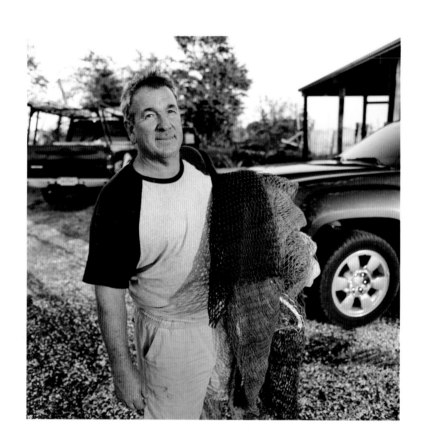

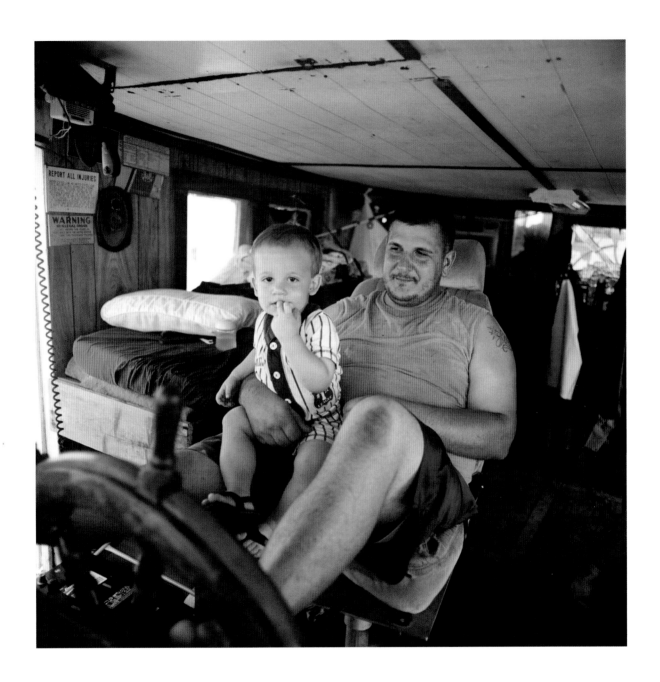

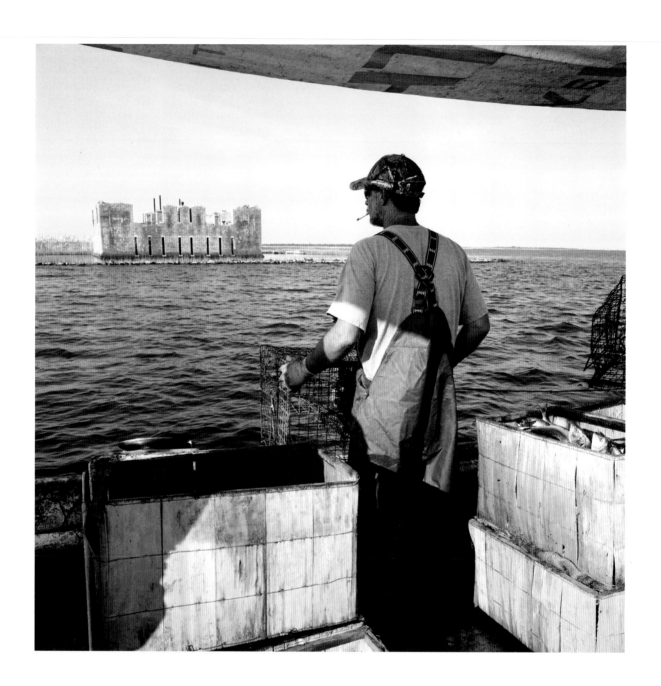

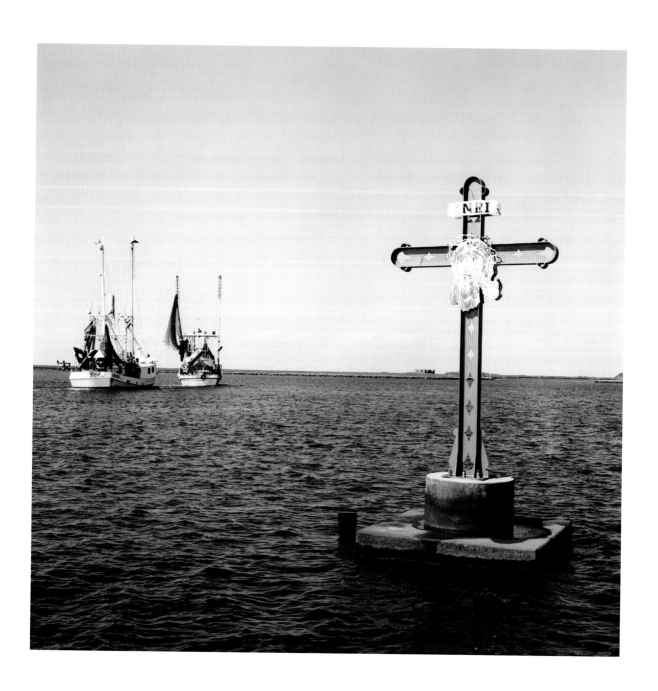

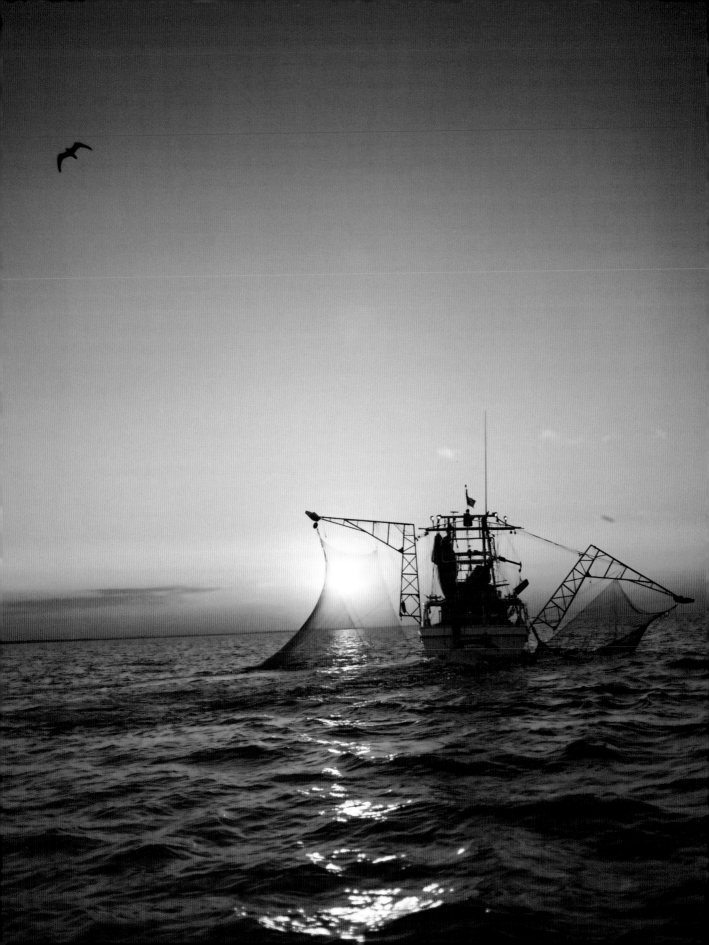

Capturing Place

CRAIG E. COLTEN

IN HIS BALLAD, "Tangled Up in Blue," Bob Dylan sang about the Louisiana fishing village of Delacroix. For him, it was one of several destinations where he sought to escape from the angst of a love gone cold. Like the West Coast and North Woods, it was a place at the edge of human experience. And, indeed, this is a place where terra firma—dry land—grades gradually into the Gulf of Mexico and where heartbreak can sink into the marsh. For most Louisiana residents who live inland, the fishing villages at the margins of coastal wetlands and open ocean are far removed from their everyday experiences. They are unknown landscapes.

It is a spongy terrain, with ever-growing bodies of open water replacing a disappearing coastline, where there is no room for cities but ample space for the valuable creatures of the coastal waters: shrimp, crabs, and oysters. Most of what passes for land on maps is a loosely knitted mass of grasses, roots, water, and sediment. This terrain is hardly solid footing for roads, which have to be built on soil borrowed from the adjacent marshes. At its highest, the land rises only a few feet above the level of the nearby water, and houses stand tall on stilts that allow storm surges to pass beneath when tropical winds blow ashore. And it is here where a determined group of Islenos, Dalmatians, Acadians, American Indians, Vietnamese, and Cambodians pursue their livelihoods. They depart from small ports and venture into the bays and the open water to collect their catches.

These citizens of the coast have adjusted to changing conditions during the past two centuries. Most were ostracized by the state's urban and Anglo population. Pushed to the marshy margins, they formed tight ethnic and family communities that sustained themselves by harvesting the creatures that thrive in this coastal territory.

Some years were good, others not so much. Yet the restaurants of New Orleans came to depend on these fisherfolk, who were the essential link between the sea and the dining table.

Along the way they have encountered hardships arising from the setting they call home. Since before the first Europeans arrived, hurricanes have battered this tenuous territory, and encounters with the oil industry, since the late 1920s, have interrupted the ecology the locals depend on. River floods that spill into the brackish waters upset the salt concentrations that sustain oyster and shrimp and temporarily disrupt residents' livelihoods. Nonetheless, they have adapted to the current ecological conditions and have built communities in this out-of-the-way wetland. And, indeed, they now think of the way things are as permanent—or at least stable. There is a myth that underlies their determination to stay in a perilous place. It is a myth that "we have been here forever, and here we will remain." This notion rejects the good-sense adjustments they have made in the past and obscures the realities of the future—although they are painfully aware of a rapidly approaching future, which is evident all around them.

They live and work in a dynamic environment. Louisiana, according to state officials, is experiencing a coastal crisis. The terra "infirma" that constitutes the buffer between the inland cities and violent weather that arrives from the Gulf of Mexico is disappearing. According to authorities, about 1,800 square miles of coastal lands have disappeared since the 1930s. This environment is a victim of naturally occurring subsidence of the heavy delta soils, erosion due to canals dug to permit oil extraction, and redirection of the essential land-building sediments into the Gulf by massive levees. Throughout the coastal margins, "ghost trees" stand as sentinels of a time when the land was higher and their roots remained above the saltwater-saturated soil.

As the state mounts a massive campaign to restore the coast, its designs pose threats to the survival of the remaining fisherfolk. To offset the land-loss juggernaut, Louisiana is undertaking projects to bulk up the barrier islands, create new marsh, and fortify levees and other structural protections. Some of the projects—part of a fifty-year plan with an estimated cost of $50,000,000,000—will undoubtedly impact these resource-reliant residents.

A key component of the state's plan is the creation of a sediment diversion in lower Plaquemines Parish, which straddles the final segment of the Mississippi River. While the river is rich in sediment, the wetlands have been starved of this restorative substance for decades. The idea is to create an engineered structure to allow a portion

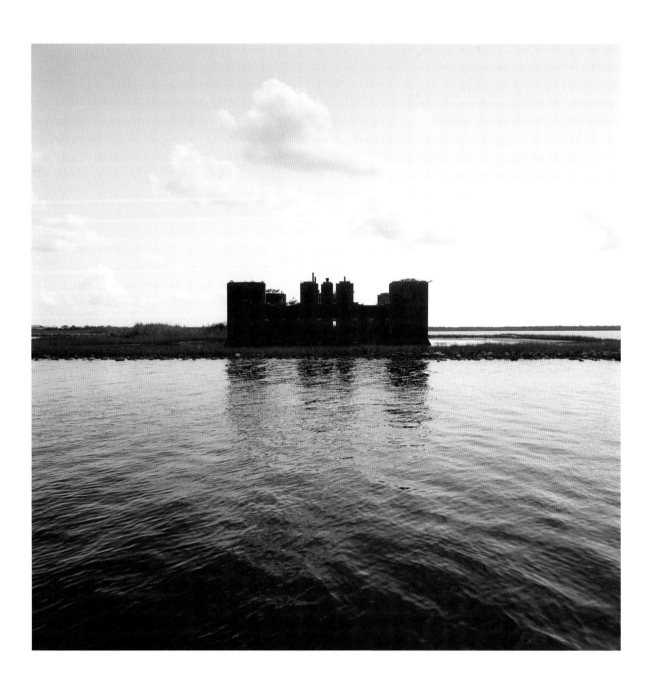

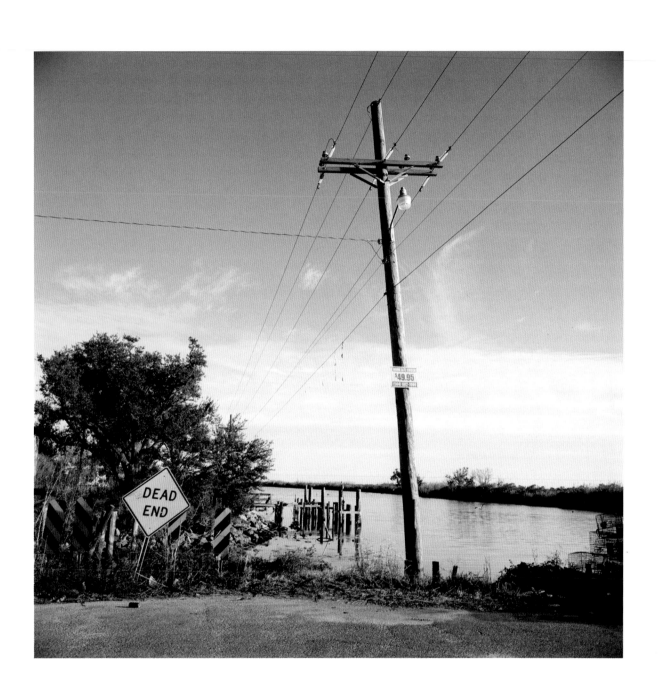

of the Mississippi River to flow into Barataria Bay during the annual spring flood. This would restore the delivery of sediments into the still waters of the bay, where they would settle out and mimic the natural process of delta building. Yet, in the short term, a fine layer of sediment would cover the oystermen's leased water bottoms and potentially destroy their "crops." Fresh river water would also drive bay shrimp farther out from the fishing ports and increase fuel costs, cutting into narrow profit margins.

The state planners have encountered staunch resistance from coastal fisherfolk, who argue for modest-sized projects that will not destroy the sea life they depend on. They are not against saving the coast, which is, after all, their home. Nonetheless, they seek a more gradual approach that is not tied to political seasons and one that will be assured of long-term fiscal commitments. There is also a cynicism among government officials, who, off-the-record, point out that the current generation of fishermen are discouraging their sons from pursuing their profession and will retire in the next twenty years or so. This sequence, they hope, will allow the opposition to disappear through attrition and enable the projects to proceed without continued resistance.

The fishing communities and fisherfolk that J. T. Blatty captures so powerfully present an ironic landscape. Fiercely dedicated to their place in the world and their way of life, they are an understandably proud people. Yet outsiders may see the derelict boats and ramshackle houses as landscapes of neglect. It is important to understand that living on the margins of habitable terrain across the globe presents similar landscapes. On the banks of James Bay (at the southern end of Hudson Bay) in Canada, for example, there is a comparable accumulation of northerly latitude debris—rusting snow plows and snowmobiles. It is simply too costly to haul worn-out equipment back to places where they can be easily recycled. Likewise in coastal Louisiana, when a boat goes down due to obsolescence or damage, it is allowed to decay in place, respectfully. Houses—be they trailers or more permanent abodes—have often been viewed by residents as expendable. Why invest everything in a house that the next hurricane may destroy? Modest dwellings can be rebuilt more efficiently after devastation. Fishing boats are more important to protect during a storm. They can ensure renewed income after a tropical cyclone. Expensive and sturdy dwellings have been considered a poor investment and an extravagant luxury.

In the narrow villages that line the roads and bayous that stretch out toward the Gulf of Mexico riches are measured in the proximity of family and the skills used to bring in a catch. College coursework is less important than local expertise. Fisherfolk have earned their experiential bachelors and masters degrees in the ecology of shrimp,

oysters, and crabs; in the economics of global markets for seafood and fuel; in the lived dynamics of community sociology.

In nearby New Orleans, there is a growing movement to reject traditional practices in fending off storms with levees and costly structures. The mantra is now "learn to live with water." The residents of the coastal fishing communities long ago learned that lesson. They have adapted, repeatedly, generation after generation, to changing environmental, economic, and political conditions. As the state pursues its coastal restoration projects, which will create additional lines of defense for the state's biggest city, the fisherfolk will be asked to learn to live with the "new water, " to adapt again.

The shrimp, oysters, crabs, and fish of the coastal waters have remained the same in biological terms. The markets and methods of collection, delivery, and consumption, however, have changed during the last century. For residents of these fishing villages, sustaining their families in this precarious setting has demanded a remarkable amount of adaptation. Will the next round of deliberate environmental alterations disconnect these residents from their livelihoods, or will they remain tethered to the consumers in the urban restaurants?

During her many visits to coastal Louisiana, J. T. Blatty came to know well these tenacious communities of fisherfolk, young and old, who have managed to stay afloat following hurricanes and oil spills. She offers us a rare glimpse into their difficult but unique lifestyles through an unusual photographic mix of landscapes and portraits, of work and home, of natural beauty and human artifice. It is this mixture that opens a meaningful vista into this remote yet nearby place, where families with deep roots in their community toil and send their annual seafood harvest towards the inland restaurants and grocers. That harvest leaves their landscape, headed to ours. In her rich collection of photographs, Blatty provides a bridge to that point of departure, and, in the process, she has mastered the art of "capturing place" for all to see.

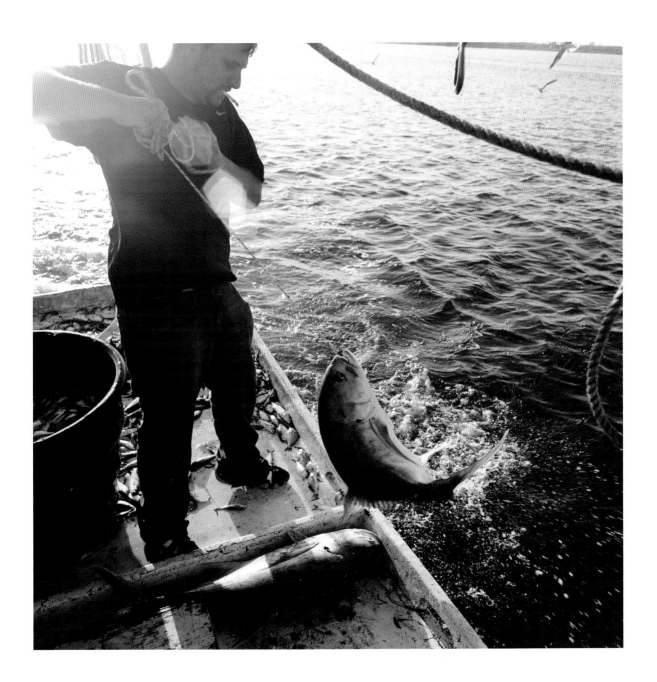

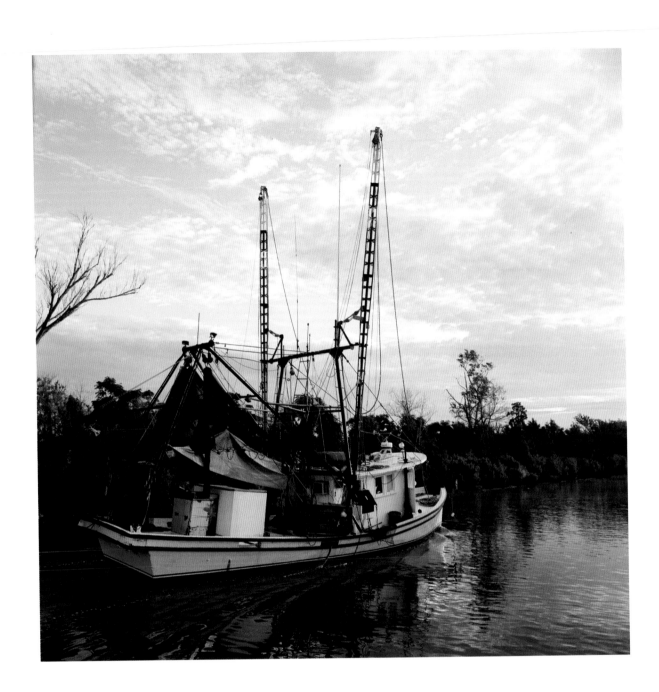

Notes on the Photographs

All photographs were made by J. T. Blatty in southeastern Louisiana from 2012 to 2017, except for the photograph of her grandmother on page 15. See "About the Craft" (page 191) for details about the author's camera and her approach to photography for this project.

1–6 Aerial views of the Breton Sound Basin. Pages 2–3 are over Delacroix. Yscloskey, Alluvial City, Shell Beach, and Hopedale can be seen in the background on page 3; pages 4 and 6 are over the Yscloskey, Alluvial City, Shell Beach, and Hopedale area and show where the U.S. Army Corps of Engineers dredged through the town of Shell Beach to create the MR-GO; pages 4 and 6 also show the remains of old Shell Beach, the land mass separating the MR-GO and Lake Borgne (surrounded by barriers to prevent further loss of land). Before the MR-GO, Bayou Yscloskey fed directly into Lake Borgne, and Shell Beach extended all the way to Fort Proctor (1856) and the old World War II Navy Base (seen best on page 6, where Lake Borgne is the lower body of water), which was then on land. Note: The acronym MR-GO (or "Mister Go") refers to the Mississippi River-Gulf Outlet, a seventy-six-mile navigation (ship-moving) channel constructed from 1958 to 1965 by the Corps of Engineers from the heart of New Orleans to the Gulf of Mexico. The dredging caused the loss of approximately 19,000 acres of wetlands and converted an additional 30,000 acres from freshwater to brackish habitats or brackish to saltwater habitats. The outlet was officially closed in 2012 after numerous people blamed the channel as the cause of enormous flooding during the aftermath of Hurricane Katrina (2005).

8 Charles Robin III, a seventh-generation commercial shrimper from Yscloskey, sits on the stern of his wooden, double-rig skiff, the *Ellie Margaret*, built by his

late father in their backyard when Charles was a teenager. Charles holds a wooden model of the same boat, also made by his father; the craft has become a family tradition. This photograph was exhibited at the Ogden Museum of Southern Art in New Orleans during the 2012 *Currents* exhibition.

10 A "whitey," or white shrimp, on the deck of the *Ellie Margaret* in Yscloskey.

15 My grandmother, Shirley Swedlund Tuero (1921–2014), who lived in New Orleans for most of her life, fishing on the Louisiana coast. Photographer and date unknown.

17 Bayou la Loutre from LA 300 in Delacroix.

19 A brown pelican flies over Bayou la Loutre in Delacroix.

20 Bayou la Loutre in Florissant.

21 Dead trees along LA 46 in Florissant.

23 Intersection of Bayou la Loutre and a canal in Delacroix.

25 Bayou la Loutre in Yscloskey, with the Yscloskey gas plant in the background. The gas plant was dismantled in 2015. This photograph was exhibited at the Ogden Museum of Southern Art in New Orleans during the 2015 *Currents* exhibition.

27 Crab traps in Delacroix. This photograph was exhibited at the Ogden Museum of Southern Art in New Orleans during the 2015 *Currents* exhibition.

28 Campo's Marina in Shell Beach, a family-run business that has catered to sport fishermen and families visiting the area for more than a century, most often locals from New Orleans breaking away from city life. According to Frank "F. J." Campo Jr., the original Campo's was built in 1903 by Celestino Campo on the old Shell Beach, back when the community resided on the shores of Lake Borgne and families from outside areas could travel by train directly to a station at Fort Proctor (Proctorville). After the Corps of Engineers dredged through old Shell Beach to create the MR-GO, the Campos rebuilt their store about a mile inland to its current location on the Yscloskey Highway.

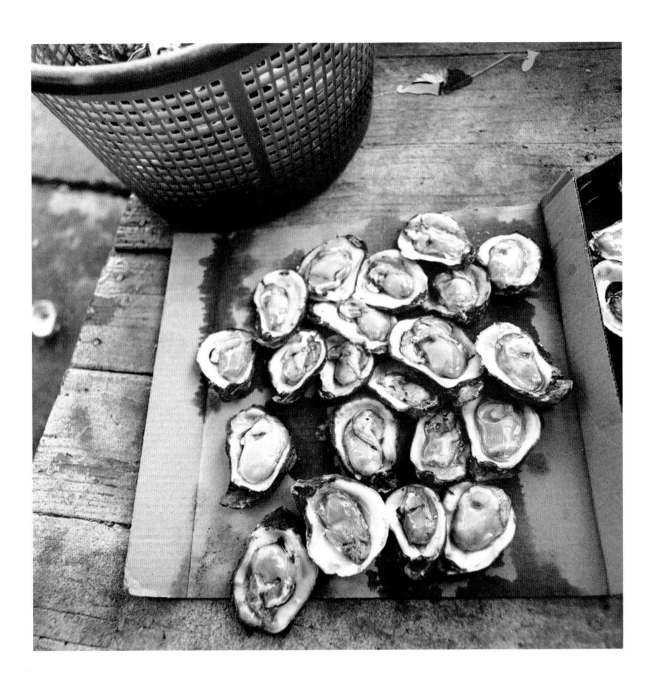

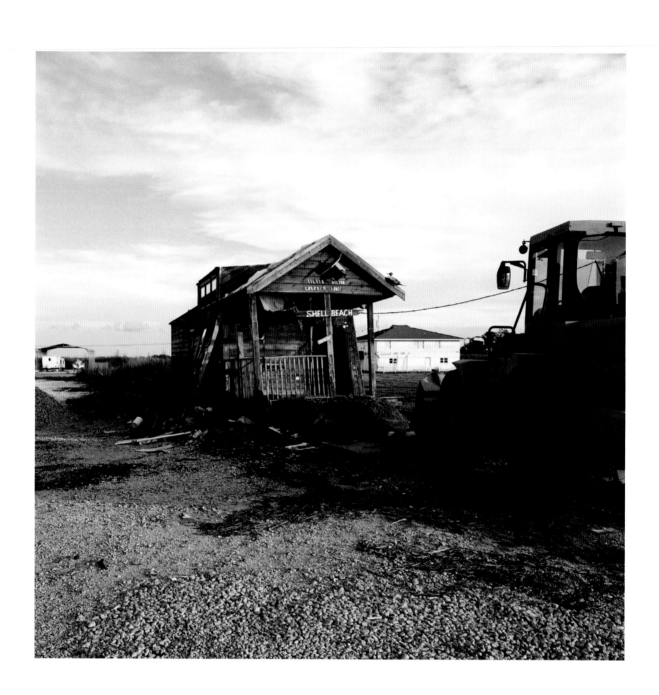

29 Trailer of Al Blappert, retired commercial fisherman, in between mountains of gravel used by his son-in-law, Greg Perez (owner of the Havana Oyster Company), to aid in harvesting oysters. According to a local oysterman, the practice of using gravel became a popular method in this area after the Deepwater Horizon oil spill (April 20–July 15, 2010) in the Gulf of Mexico when fishermen noticed the oysters' inability to cling to a hard surface, which is required for them to grow. Some suspect the dispersants during the spill were the direct cause.

30 Boat lift in Delacroix.

31 The Last Stop convenience store in Reggio.

33 Sharon's Discount in Shell Beach after reopening post-Hurricane Isaac (landfall on August 28, 2012). After rebuilding the business four times, following four devastating hurricanes, owners Douglas "Duddy" Couture and Sharon, his wife, finally closed the store in 2015 when running and maintaining it alone became too challenging.

35 Douglas "Duddy" Couture in front of Sharon's Discount, his and his wife's store, after reopening post-Hurricane Isaac in Shell Beach.

36 The Yscloskey drawbridge in St. Bernard intersects Hopedale, Yscloskey, and Shell Beach.

37 Water tower and shrimp vats in Violet.

38 The *Lady Susan*, a shrimp boat, hung up on the Yscloskey drawbridge in Hopedale following Hurricane Isaac.

39 Alan "Preacher" Squires (right), commercial crabber, and son, Thomas, prepare to pull crab traps in Shell Beach the day after Hurricane Isaac. The two were salvaging their traps from the bottom of Bayou Yscloskey after the storm's surge created havoc. This photograph was exhibited at the Ogden Museum of Southern Art in New Orleans during the 2012 *Currents* exhibition.

41 Docked fishing boats in Bayou Yscloskey.

43 Charles Robin III shucks oysters pulled from his cousin's oyster lease during a shrimping trip while his deckhand empties the ice hole of shrimp at the dock in Shell Beach.

44 Sorting through blue crabs at the Shell Beach Seafood Company, a crab and oyster dock in Hopedale.

45 Winter fishing in Bayou Yscloskey.

46 Al Blappert, retired commercial fisherman and firefighter, at his former home in Shell Beach that he named the "Tiltin' Hilton Crooked Lodge" (see page 170) and which was demolished by Hurricane Isaac (landfall on August 28, 2012). Before building his home here, Al lived in the bayous off of Hopedale, where he was only accessible by boat. Hurricane Katrina (landfall on August 29, 2005) forced him to leave, as that storm forever submerged the land there.

47 Fisherman's closet.

48 Charles Robin III in the cabin of the *Ellie Margaret*, on the radio with other commercial shrimpers as he prepares to depart for a weeklong trip from Yscloskey. This photograph was published on *CNN Photos* (December 1, 2013).

51 The *Ellie Margaret* (boat of Charles Robin III) and the *Lil Charlito* (boat of Charles Robin IV) in the far-right background skimming for white shrimp in Lake Borgne. Skimming is often the practice used in shallower waters, but trawling nets are used in deeper waters. This photograph was exhibited at the Ogden Museum of Southern Art in New Orleans during the 2015 *Currents* exhibition.

52 Charles Robin IV, inside the hull of *Lil Charlito* in Yscloskey, performs maintenance after an unexpected mechanical problem halted his fishing trip.

53 Charles Robin IV in the captain's seat of his smaller shrimp boat, the *Mr. Charlito*, as he heads out from Yscloskey at dawn for a day of fishing during brown shrimp season. This photograph was published on *CNN Photos* (December 1, 2013).

54 Charles Robin IV (left) and deckhand Corey Ruiz trawl for brown shrimp in the MR-GO on the *Mr. Charlito*.

55 "Brownies," or brown shrimp, heaped on the sorting table of the *Mr. Charlito* in Lake Borgne. This photograph was published on *CNN Photos* (December 1, 2013).

57 Porpoises follow the *Mr. Charlito* in the MR-GO.

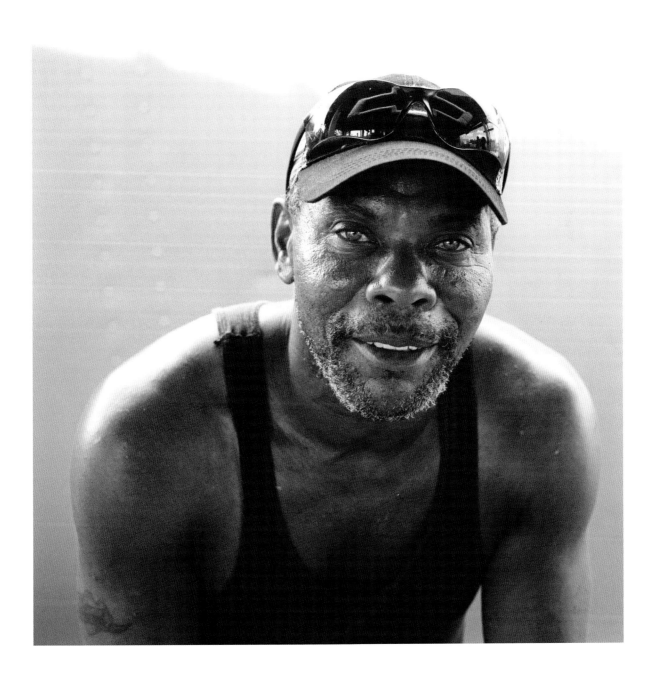

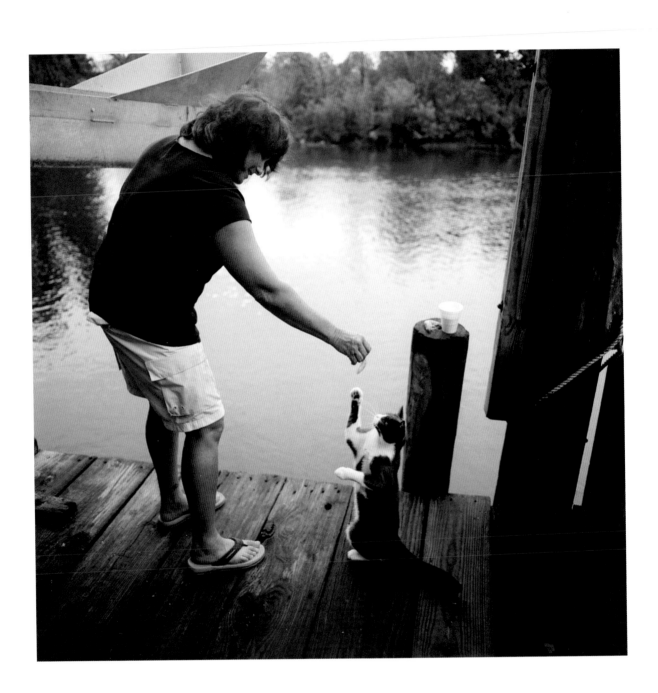

59 Trawling for shrimp on the *Mr. Charlito* in the MR-GO, while, in the background, smoke rises as debris from Hurricane Isaac burns near Shell Beach. This photograph was published on *CNN Photos* (December 1, 2013).

61 Hand-painted sign on an ice container outside the Breton Sound Marina in Hopedale. This photograph was published on *CNN Photos* (December 1, 2013).

62–67 Net's Rock-N-Dock in Shell Beach, a wholesale, local shrimp-buying business owned by Lynette Gonzales. On page 62, Joseph Fernandez prepares to offload shrimp; on page 63, Bernard Naquin (left) and Corey Bendich play darts in between arrivals of shrimp boats; on page 64, Corey takes a break in between the arrival of shrimp boats; on page 65, he pulls the conveyor belt down to a shrimp boat to offload shrimp; on page 66, Joseph offloads brown shrimp from the ice hole of a shrimp boat onto the conveyor belt for weighing; and, on page 67, Sheila Smith tips the weighing basket of brown shrimp into an iced vat, while Lynette Gonzales counts shrimp (calculates how many shrimp to a pound for this specific catch).

68 Empty shrimp vats in Shell Beach.

69 Commercial shrimper Yancy Matherne sports his customized shrimper boots, called "Cajun Reeboks" by many in the bayous of Louisiana.

70 Lynette Gonzales, owner of Net's Rock-N-Dock in Shell Beach, stands in front of her stilted camp across from her business on Bayou Yscloskey. Lynette grew up in Hopedale and used to work as a deckhand for her father, Rudy Gonzales, a retired shrimper.

73 Ross Robin (left) and Charles Robin IV hang the American flag from the rigs of their father's decorated boat, the *Ellie Margaret*, prior to the Blessing of the Fleet ceremony at the start of the shrimping season in Yscloskey.

74–76 Decorated fishing boats in Bayou la Loutre during the Blessing of the Fleet ceremony conducted by Archbishop Aymond in Hopedale (pages 74 and 76) and Delacroix (page 75).

77 The Fourth of July flotilla in Lake Borgne.

79	Shrimp boats (including the *Ellie Margaret* on the right) en route to Lake Borgne for a celebration with their owners' friends and family after receiving a blessing during the Blessing of the Fleet ceremony in Hopedale.
81	Fisherman's daughters: Curstin (left) and Rosa Perez, daughters of oysterman Greg Perez, on their father's boat in St. Bernard.
82	Al Blappert picks his home-grown Creole tomatoes in Shell Beach.
83	Looking through the kitchen window of the *Ellie Margaret* in Ysclockey.
85	Charles Robin IV and his dog, Bruiser, on the deck of the *Ellie Margaret* in Yscloskey.
86	(Left) Lisa Robin, wife of Charles Robin III, brings soft-shell shrimp for Charles to fry at a special gathering of family and friends in Yscloskey; and (right) sorting white shrimp on the deck of the *Ellie Margaret* (boat of Charles Robin III).
87	Charles Robin III frying soft-shell shrimp for family and friends in Yscloskey.
89	Brothers Ross (right) and Gabriel Robin head out on Bayou la Loutre in Yscloskey to hunt nutria.
91	Bayou la Loutre in St. Bernard.
92	Approaching the crab trap buoy.
93	Preacher Squires, commercial crabber, on Bayou Yscloskey. This photograph was published on *CNN Photos* (December 1, 2013).
95	Thomas Squires, Preacher's son, is pinched by a blue crab in the Lake Borgne area while grading crabs. Following Hurricane Isaac, ice was unavailable to the commercial fishermen. Without ice to pack, which calms down the crabs, suffering from a crab bite is common (and far more painful than most perceive). This photograph was exhibited at the Ogden Museum of Southern Art in New Orleans during the 2012 *Currents* exhibition.
97	Preacher and deckhands Derrick Bennett (right), the shaker and baiter, and Peter Walgamotte (left), the grader, head out for a day of pulling crab-traps near Shell Beach. Preacher and his crew pull 400–700 traps per trip and often make five or six trips per week during peak season. This photograph was published on *CNN Photos* (December 1, 2013).

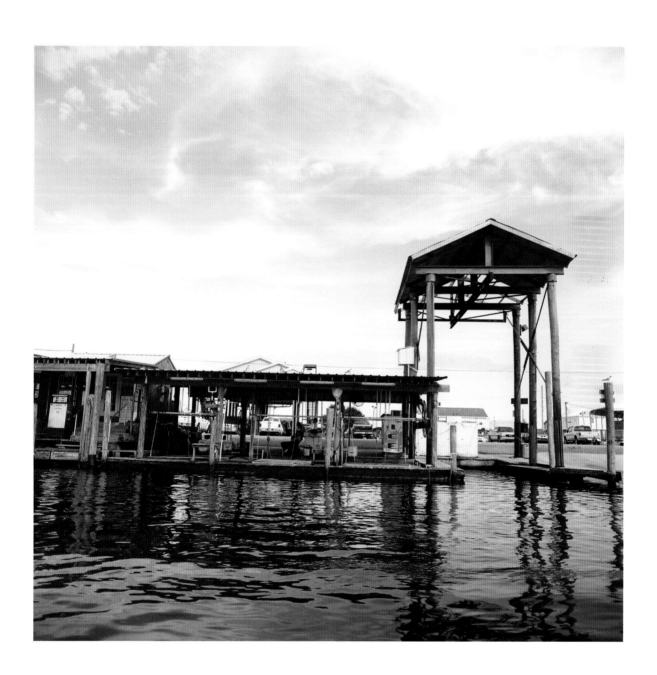

98 Preacher Squires and sons Thomas Squires and Justin Jones pull crab traps near Shell Beach. When crabbing, Preacher hooks the buoy (attached to the crab trap underwater) while simultaneously driving the boat. The deckhands proceed to take the trap, shake the crabs out, grade them by size, and the last deckhand baits the trap and throws it back into the water.

99 Scenes from crabbing on Preacher's boat.

101 View from the captain's chair on Preacher's boat.

102 Male (left) and female (right) grade-A blue crabs, the largest grade on the market, on Preacher's boat. Blue crab genders are identified by the patterns on their undersides.

103 Thomas Squires (left) and Justin Jones pulling traps.

104 Preacher on his boat early in the morning.

107 Early morning on Lake Pontchartrain from the bow of Rocky Rakocy's fishing boat. He chops live eel into pieces to bait his catfish lines.

109 Rocky Rakocy, a commercial fisherman (catfish and crab), looks to pull a catfish along a trotline in Lake Pontchartrain near Manchac. Rocky sometimes has up to nine spans of trotline, each approximately 1,000 feet long, with eighty hooks strung along each. This photograph was published on *CNN Photos* (December 1, 2013).

110 Rocky Rakocy's spools of catfish line outside his camp in Manchac.

111 (Left) Rocky Rakocy holds a catfish pulled from his trotline; and (right) Rocky's haul of fresh filleted catfish. Historically, Manchac was and still is famous for fresh catfish, but, nowadays, Rocky Rakocy is one of the few locals still fishing for them commercially in the Manchac area.

112 Rocky Rakocy, also a commercial crabber when not fishing for catfish, chats with passing crabbers on the Highway 51 canal at his camp in Manchac.

113 Brown pelicans wait for scrap fish near Rocky's camp in Manchac.

114 Rocky Rakocy inside his camp on the Highway 51 canal in Manchac.

117 Al Blappert and his dog, Blue, inside his former home, the "Tiltin' Hilton Crooked Lodge," in Shell Beach, prior to its destruction on August 28, 2012, by Hurricane Isaac. This photograph was exhibited during the 2014 *New Orleans in Photographs* exhibition at the Multi-Media Museum-Moscow House of Photography in Moscow, Russia. (See the note for page 46 for more information on Al.)

118 Inside Al Blappert's trailer in St. Bernard, where he temporarily relocated after Hurricane Isaac destroyed his home in Shell Beach.

119 Al Blappert and his granddaughter, Havana Perez, daughter of Greg Perez (owner of the Havana Oyster Company), sit on the steps of his trailer in St. Bernard.

121 Al Blappert and his dog, Rebel, at home in St. Bernard.

122 Mementos of Hurricane Katrina (2005) inside Al Blappert's trailer in St. Bernard. According to Al, during Hurricane Katrina, he stayed in St. Bernard Parish on the north side of the levee and sheltered at least fifteen dogs, five cats, one parrot, and one parakeet, all belonging to residents who evacuated and could not take them. He and the pets were confined to a room on the second story of a house for seven days. He safely returned all of them to their owners.

123 (Left) Fresh oysters from Al Blappert's son-in-law, oysterman Greg Perez, shucked and ready to eat at Al's trailer in St. Bernard; and (right) a memento on the wall honors "Lexie Girl," Al's former dog that lived to be nineteen years old, inside his trailer in St. Bernard.

124 Al Blappert stands on the porch of his former home, the "Tiltin' Hilton Crooked Lodge," in Shell Beach, prior to Hurricane Isaac.

127 Shell Beach following Hurricane Isaac.

128 Shell Beach following Hurricane Isaac. This photograph was published on *CNN Photos* (December 1, 2013).

129 Charles Robin III (left) and a friend assess the damage of a shrimp trawler following Hurricane Isaac in Yscloskey.

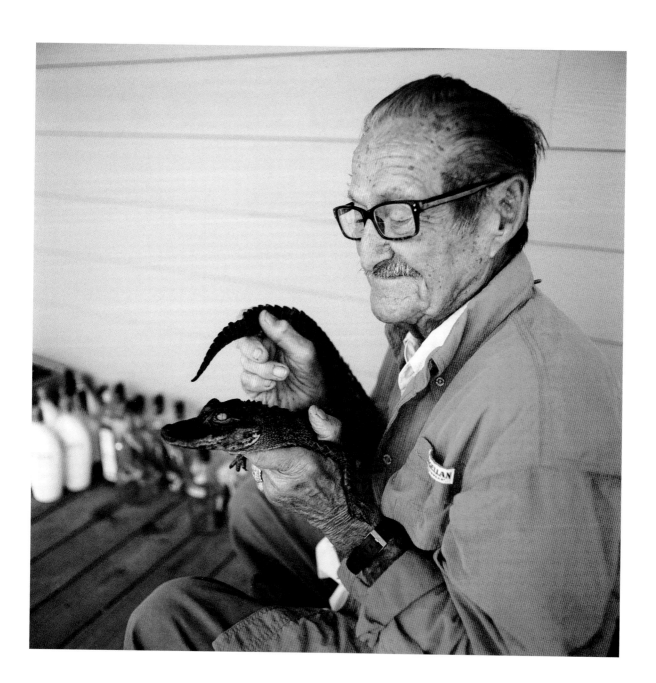

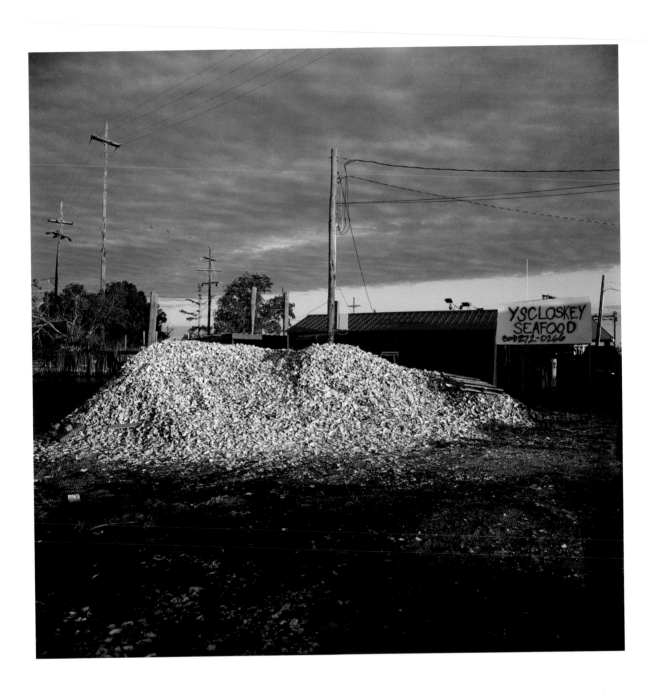

130 LA 46 near Yscloskey; the gas plant in the background was dismantled in 2015.

131 Flooded land in Florissant following Hurricane Isaac.

132 The LA 46 floodgate in St. Bernard is the portal between protected land "up the road" and vulnerable wetlands "down the road."

133 Aerial view of the LA 46 floodgate in St. Bernard. The beginning of Black Bay and the Gulf of Mexico are visible at the top.

134 Halloween spirit on the Yscloskey Highway in Shell Beach.

135 According to local residents, this is an old concrete flag post in Alluvial City that indicates where the Sebastien Roy Elementary School once catered to children of the St. Bernard fishing communities, until Hurricane Betsy demolished it on September 9–10, 1967. After Betsy, the school reopened closer to the floodgate in Reggio but then permanently closed after Hurricane Katrina in 2005.

136 The old basketball court of the former Sebastien Roy Elementary School in Alluvial City. This photograph was exhibited at the Ogden Museum of Southern Art in New Orleans during the 2012 *Currents* exhibition.

137 Pilings from a former structure in Alluvial City after Hurricane Isaac.

139 A dead green heron in Alluvial City. This photograph was published on *CNN Photos* (December 1, 2013).

140 The changing landscape—of dead trees—in Hopedale.

141 Yscloskey following Hurricane Isaac.

142 Bayou la Loutre after Hurricane Isaac. This photograph was exhibited at the Ogden Museum of Southern Art in New Orleans during the 2012 *Currents* exhibition.

143 Bayou la Loutre in Hopedale after Hurricane Isaac.

144 Remains of the Shell Beach World War II Anti-Aircraft Training Base, now surrounded by water in Lake Borgne. The old base, like historic Fort Proctor, was accessible by road and train before the MR-GO separated the community

from the mainland. A patriotic fishing community learned to live peacefully with the sudden arrival of the base and outside soldiers. Frank "F. J." Campo, Jr., of Campo's Marina, can even recall how his mother would make sandwiches for the soldiers training on the base and how, as a little boy, he would sit on the side of the road mesmerized as he watched the big military trucks driving by his home.

147 Reflection of an oyster boat in Bayou la Loutre in Yscloskey. This photograph was published on *CNN Photos* (December 1, 2013) and in *The Oxford American* (Fall 2014): 4.

149 Alluvial City native Edward "Doogie" Robin, former commercial shrimper and owner of Robin Seafood, holds a photograph of Shell Beach (now called the "old" Shell Beach) prior to the dredging of the MR-GO, when the town rested on the edge of Lake Borgne and Bayou Yscloskey ran directly into the lake. One can see residential houses and the old World War II Navy Base.

151 Charles Robin III and his granddaughter, Anna Lee Robin, hold fresh white shrimp on the deck of the *Ellie Margaret* in Yscloskey. This photograph was exhibited at the Ogden Museum of Southern Art in New Orleans during the 2015 *Currents* exhibition.

152 Frank "F. J." Campo, Jr., stands in front of his century-old, family-run business, Campo's Marina in Shell Beach.

153 This old photograph inside Campo's Marina in Shell Beach portrays the legendary Blackie Campo (left), who passed away in 2009, and his father, Celestino Campo, who started the business, boasting a line of fresh-caught redfish, trout, sheepshead, and drum. In the photograph, assumed to have been taken by family friend Jack Romaine, Blackie and Celestino stand near their home on the old Shell Beach. Frank "F. J." Campo, Jr., son of the legendary Blackie Campo and grandson of Celestino Campo, estimates the year to be 1953, based on the appearance of the oak tree in the background. If the tree was crooked, he knows it was after Hurricane Flossy hit in 1956; if straight, it was prior to Flossy.

154 Charles Robin III holds shrimp nets in Yscloskey.

155 Charles Robin IV and his son, Charles Robin V, at the helm of the *Lil Charlito*, as they trawl in Lake Borgne.

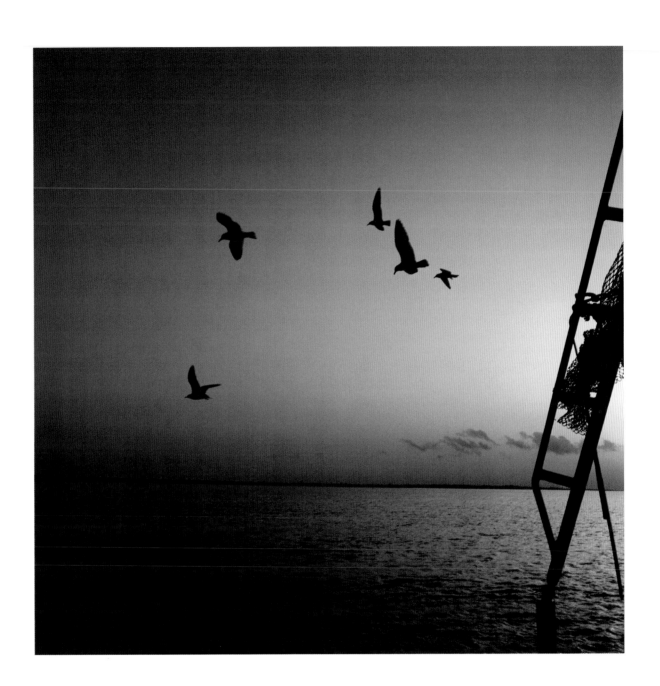

156 Thomas Squires looks towards Fort Proctor from the deck of his dad's crab boat.

157 Charles Robin III's *Ellie Margaret* pulls the *Little Robin*, boat of his oldest brother, Ricky Robin, to a shipyard for repair after the shaft broke. The Hurricane Katrina Memorial (right) was erected in 2006 during the first year of recovery from the catastrophic storm in honor of the 163 individuals who lost their lives in St. Bernard Parish.

158 Skimming for white shrimp on the *Ellie Margaret* (boat of Charles Robin III) in Lake Borgne.

161 Fort Proctor, also known as Fort Beauregard or Beauregard's Castle, was built in 1856 at the edge of old Shell Beach (also known as Proctorville) on Lake Borgne. It was part of a permanent national system of forts authorized for development by the U.S. Congress to defend routes that could be used for invasion following the War of 1812. The fort, still unfinished due to a hurricane in 1860, was seized by the state and used as a minor lookout post for the Confederates during the Civil War. It was added to the National Register of Historic Places in 1978.

162 Dead end: where land and water meet in Delacroix.

165 Corey Ruiz, deckhand to Charles Robin IV, catches an amberjack with a hook and string on the *Lil Charlito* in Lake Borgne. This photograph was published on *CNN Photos* (December 1, 2013) and exhibited at the Ogden Museum of Southern Art in New Orleans during the 2015 *Currents* exhibition.

166 Charles Robin IV heads out on Bayou Yscloskey to deeper waters for a shrimping trip in a boat he named after his son, the *Lil Charlito*. Charles used to captain a smaller boat—the *Mr. Charlito*—that was more appropriate for day trips near shore, but he then invested in this larger vessel that can easily be taken to sea for weeks at a time due to sleeping space, a kitchen area, a larger fuel tank, and more space to ice the shrimp. This photograph was published on *CNN Photos* (December 1, 2013).

169 Fresh-shucked oysters getting ready to roast for Fourth of July celebrations in Shell Beach.

The cover: Brown pelicans and other bird species gather in and around cypress trees in Venice. Due to the vanishing coastline, birds migrating from Mexico to Louisiana's wetlands along the Gulf of Mexico are forced to travel greater distances every year to reach land, resulting in declining populations.

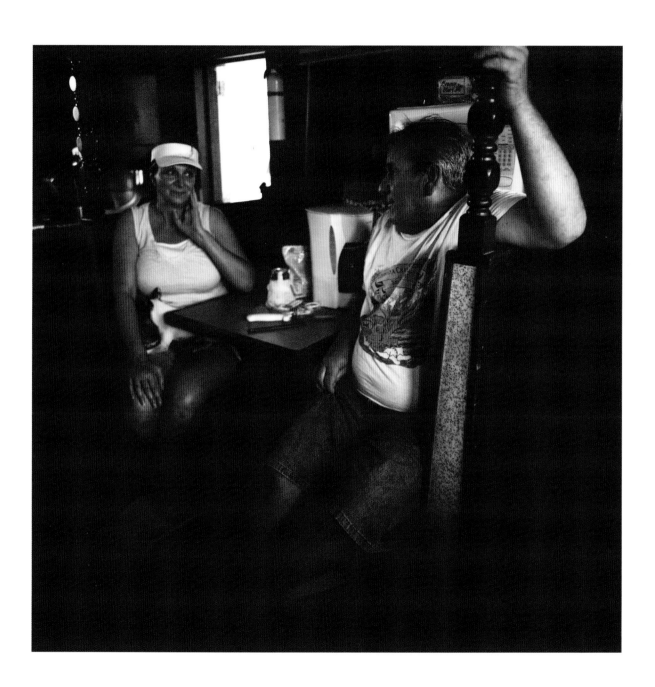

About the Craft

I grew up during the transition of film to digital photography, and by the time I pursued photography as a career, digital had become the industry standard. I bought my first SLR digital camera and taught myself manual photography, reading the instruction booklet chapter by chapter and bothering people to no end on online photography forums.

A few years later, curiosity and a recommendation from my mentor, Zig Jackson, led me to take an undergraduate course in black-and-white photography and film development in a darkroom. How could I be a true photographer without understanding manual film photography or without understanding the darkroom? The class opened an entire new world to me, and my love for photography grew exponentially.

I still use digital for my commissioned work, but, with *Fish Town*, I wanted film. I find that the world of digital photography allows me to rush, too often with the ability to revise an exposure immediately, and I take far too many pictures knowing that running out of film won't be an issue. With film, I slow down and allow myself to be more present and connected to what and who I am photographing and appreciate each exposure with only twelve to a roll of 120mm film.

Before I began my search for a camera, I asked my printer, a photographer from the film era, for a recommendation. Within minutes, he was dusting off an old Zenza Bronica SQ-A and a Minolta light meter and sold them to me for $100.00. *Fish Town* has been entirely photographed with this camera, and over the years I have come to appreciate it even more, for it allowed me to create a tangible archive of land and life that is not easily forgotten.

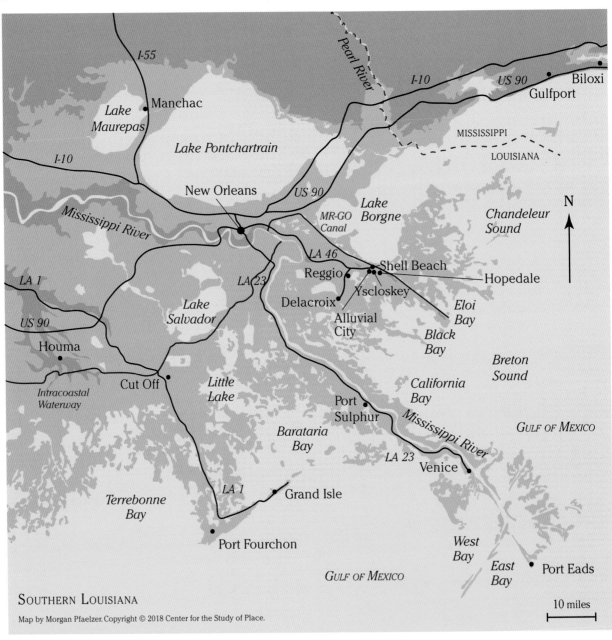

SOUTHERN LOUISIANA

10 miles

This map shows key locations, bodies of water, and flood-prone areas (in yellow) in southern Louisiana with a current elevation of one meter (3.3 feet) or less above sea level. Reliable scientific models project the sea to rise globally at least one meter within a century, impacting these low-elevation areas further. Significantly, storm surges along the Gulf Coast created by hurricanes such as Isaac in 2012 (4.24 meters or 14 feet) and Katrina in 2005 (a record 8.4 meters or 27.8 feet) affect even higher ground. Source: Climate Central.

About the Sources

The direct quotations that appear on pages 12 and 14 and the eighteen recollections that appear on pages 7, 34, 49, 50, 56, 60, 71, 72, 80, 90, 105, 108, 115, 116, 125, 126, 145, and 146 were excerpted for *Fish Town* from transcribed audio recordings conducted by J. T. Blatty with residents of Louisiana's fishing communities. Other sources that informed the author's introduction ("Down the Road"), captions, and understanding of Louisiana's fishing communities include:

The Associated Press, "27,000 abandoned oil and gas wells in Gulf of Mexico ignored by government, industry" (July 7, 2010); http://www.nola.com/news/gulf-oil-spill/index.ssf/2010/07/27000_abandoned_oil_and_gas_we.html.

Rex H. Caffey and Brian Leblanc, "Closing the Mississippi River Gulf Outlet: Environmental and Economic Considerations" (Baton Rouge, LA: LSU AgCenter, 2002); http://lacoast.gov/new/data/reports/its/mrgo.pdf.

Bob Marshall, a four-part series on Delacroix published in *The Times Picayune* as follows: Part One (August 1, 2010): "Gulf of Mexico oil spill is just the latest blow for Delacroix"; http://www.nola.com/news/gulf-oil-spill/index.ssf/2010/08/gulf_of_mexico_oil_spill_is_ju.html; Part Two (August 2, 2010): "Delacroix was insulated from history by wetlands"; http://www.nola.com/news/gulf-oil-spill/index.ssf/2010/08/delacroix_was_insulated_from_h.html; Part Three (August 3, 2010): "Delacroix settlers found themselves in an opulent natural bazaar"; http://www.nola.com/news/gulf-oil-spill/index.ssf/2010/08/delacroix_settlers_found_thems.html; and Part Four (August 4, 2010): "Delacroix residents 'never imagined how bad it would get'"; http://www.nola.com/news/gulf-oil-spill/index.ssf/2010/08/delacroix_residents_never_imag.html.

National Register of Historic Places database; http://www.crt.state.la.us/dataprojects/hp/nhl/attachments/Parish44/Scans/44002001.pdf.

Maida Owens, "Louisiana's Traditional Cultures: An Overview," *Folklife in Louisiana* (updated periodically); http://www.louisianafolklife.org/LT/Maidas_Essay/main_introduction_onepage.html

Lawrence N. Powell, *The Accidental City: Improvising New Orleans* (Cambridge, MA: Harvard University Press, 2012).

"St. Bernard Isleños: Louisiana's Spanish Treasure" (no author, no date); http://www.losislenos.org/history.html.

Mike Tidwell, *Bayou Farewell: The Rich Life and Tragic Death of Louisiana's Cajun Coast* (New York, NY: Pantheon, 2004).

Acknowledgments

Thanks to those who were involved in the earliest stages of this project in Savannah, Georgia: Nash MacIntosh, who is no longer with us, for sharing his love of the water and introducing me to the magic of the Low Country; Rusky Fleetwood, author of *Tidecraft: The Boats of South Carolina, Georgia, and Northeastern Florida, 1550–1950* (1995), for his advice and inspiration; Jim Morekis, Editor-in-Chief of *Connect Savannah Magazine*, for encouraging and publishing my first stories on the subject; to Tess Riter, my friend and editor, for the hours of free editing over Skype; Zig Jackson, for believing in me as a photographer during my earliest years; Nizar Mouna and Adonis Mouna at Photomaster, for the endless hours of printing; and, again, to Nizar, for essentially giving me the camera I used for this project.

Thanks, also, to those at the Center for Documentary Studies at Duke University, for giving me the focus and encouragement to bring my scattered idea to life, especially Alexa Dilworth, April Walton, and Kara Oehler; Ben Pagac, for teaching me the skills to capture audio and integrate it into my story; and Leah Sobsey, for direction and mentorship during the earliest phases of this project, when I was still photographing all over the Gulf Coast.

Special thanks, also, to Jamie Wellford, for never forgetting me or the project; Craig E. Colten, for his unlimited knowledge on the subject of *Fish Town* and his beautiful concluding essay; and Susan Guice, for flying me over the Louisiana coast to capture aerial photographs that are integral to the understanding of the book.

To the fishermen of Louisiana's coast, thank you for the time spent taking me out on the water, sending me home with fresh seafood, and sharing your lives and stories with me: Rocky Rakocy, Charles Robin III and family, Alan "Preacher" Squires, Lynette Gonzales, and Al Blappert, whom I met the first time I drove "down the road" in 2010.

Thanks, also, to the other men and women I photographed, recorded, and spent time with outside of Louisiana: Charlie Teeple, who is no longer with us, Selma "Pee Wee" Weil, and Gale Williams, of Thunderbolt, Georgia; Algie Varn, of Pin Point Island, Georgia; and Lawrence Johnson, of Bayou la Batre, Alabama. You may not appear in this book, but you're an integral part of it.

I am forever grateful to the backers of this book, including Linda Tuero Lindsley, David William Paul, Jennifer Tuero Melius and Dr. Brian Melius, and Barcadia New Orleans. I also thank Captain Lloyd Landry, of Outcast Fishing Charters; musician Benny Grunch; Two Girls One Shuck, the New Orleans traveling oyster bar; and the New Orleans Photo Alliance, for your generosity during fundraising. Without all of you, the publication of this book would have been impossible.

Special thanks to Mikki Soroczak, for her editorial and research assistance; to David Skolkin, for his masterful book design, art direction, and contributions to the final sequence; and to George F. Thompson, my editor and publisher, for believing in and improving this book from the beginning to the end.

Finally, thank you, Deya Rairan, for never declining an adventure down a two-way road to the bayous, for always being my partner in crime, and for encouraging the project eternally. And, last but never least, to my Dad, William Peter Blatty, who passed away before this book was printed, for inspiring me to be the artist he recognized long before I ever did.

About the Author and the Essayist

Jenn Tuero (J. T.) Blatty was born in New Orleans, Louisiana, in 1978. She graduated from the United States Military Academy at West Point in 2000 and served six years as an active-duty U.S. Army officer, which included first-rotation combat deployments into Afghanistan and Iraq. In 2006, after completing her service to the military and inspired by a love of capturing life, people, and her personal experiences with disposable cameras, notebooks, and pens, she pursued photography and writing as a career, beginning as a regular contributing photographer and writer for *Connect Savannah Magazine* in Georgia. In 2010, after a photography internship with *National Geographic Traveler*, she returned to New Orleans, where, in addition to working commissions for private and commercial clients, she is a correspondent with *The New Orleans Advocate* and a FEMA Disaster Reservist photographer. Blatty's work has been exhibited in the Multimedia Moscow House of Photography in Russia, Borges Cultural Center in Argentina, Detroit Center for Contemporary Photography, and, on multiple occasions, the Ogden Museum of Southern Art in New Orleans, among other museums and galleries. Her photographs and articles have appeared in *CNN Photos, Charleston* (SC) *Magazine, National Geographic Traveler, Newsweek/The Daily Beast, The Oxford American, Savannah Magazine, Smithsonian Magazine,* and *USA Today,* among others. In between photography projects and commissions, Blatty has been writing a book about her experiences in the military during a time of combat and the challenges and adaptations she faced as a young adult graduating from West Point a year before 9/11.

Craig E. Colten is the Carl O. Sauer Professor of Geography at Louisiana State University and the author of *An Unnatural Metropolis: Wresting New Orleans from Nature* (LSU Press, 2005), which was awarded the John Brinckerhoff Jackson Book Prize of the Association of American Geographers for the Best Book in Human Geography; *Perilous Place, Powerful Storms: Hurricane Protection in Coastal Louisiana* (University Press of Mississippi, 2009), and *Southern Waters: Limits to Abundance* (LSU Press, 2014). He hopes the fisherfolk at the edge of the Louisiana marshes keep landing those delicious Gulf shrimp forever.

About the Book

Fish Town: Down the Road to Louisiana's Vanishing Fishing Communities was brought to publication in an edition of 1,000 hardbound copies. The text was set in New Caledonia and ITC Cheltenham, the paper is Hano, 157 gsm weight, and the book was professionally printed and bound by P. Chan & Edward, Inc., in China.

Publisher and Project Director: George F. Thompson
Editorial and Research Assistant: Mikki Soroczak
Manuscript Editor: Purna Makaram
Book Design and Production: David Skolkin

Special Acknowledgments: The publisher extends special thanks to Jenn Blatty, for entrusting her work to our care, to those donors who supported *Fish Town,* and to David Wharton, Director of Documentary Studies at the Center for the Study of Southern Culture at the University of Mississippi, Martha A. Strawn, Professor of Art Emerita at the University of North Carolina, Charlotte, and Alexa Dilworth, Publishing Director and Senior Editor at the Center for Documentary Studies at Duke University, for their advice and counsel during the editorial development of this book.

Published 2018. First hardcover edition.
Printed in China on acid-free paper.

George F. Thompson Publishing, L.L.C.
217 Oak Ridge Circle
Staunton, VA 24401–3511, U.S.A.
www.gftbooks.com

25 24 23 22 21 20 19 18 17 1 2 3 4 5

The Library of Congress Preassigned Control Number is 2017918130.

ISBN: 978–1–938086–51–9